Ethical Portraits

In Search of Representational Justice

Hatty Nestor

Winchester, UK
Washington, USA

JOHN HUNT PUBLISHING

First published by Zero Books, 2020
Zero Books is an imprint of John Hunt Publishing Ltd., No. 3 East St., Alresford,
Hampshire SO24 9EE, UK
office@jhpbooks.com
www.johnhuntpublishing.com
www.zero-books.net

For distributor details and how to order please visit the 'Ordering' section on our website.

Text copyright: Hatty Nestor 2019
Edited by Rosanna McLaughlin

ISBN: 978 1 78904 002 9
978 1 78904 003 6 (ebook)
Library of Congress Control Number: 2019956587

A CIP catalogue record for this book is available from the British Library.

Design: Stuart Davies

UK: Printed and bound by CPI Group (UK) Ltd, Croydon, CR0 4YY
Printed in North America by CPI GPS partners

Supported using public funding by

**ARTS COUNCIL
ENGLAND**

We operate a distinctive and ethical publishing philosophy in
all areas of our business, from our global network of authors to
production and worldwide distribution.

Ethical Portraits

In Search of Representational Justice

What People Are Saying About

Ethical Portraits

Brian Dillon, Writer

Hatty Nestor is a writer of rare commitment, ambition and talent, whose interest in the field of criminal and carceral portraits has already produced an urgent and engaged piece of research and writing. The book outlined here mounts a timely and compelling case for such representation as more urgently than ever in need of analysis. It is intimately informed by engagement with the images in question, interviews with artists and prisoners, informed theoretical reflection throughout, and the pressing political impetus that has been at the heart of Hatty Nestor's interest in the subject.

Abi Andrews, Writer

At the intersection of criticism and ethics, *Ethical Portraits'* Hatty Nestor takes thorough care of her subjects, bringing to light images made invisible. Questioning the responsibility of artists of prison portraiture, Nestor handles this marginal subject with intimate care and ethical rigor. The theoretical exactitude applied to her subject communicates a deep empathy. This book is thorough, humane, and ultimately heartfelt. Compelling and timely, written with the commendable intention of being as open and accessible as it can, in order to share its importance as widely as possible.

James Pogue, Writer

Hatty Nestor is an important and thrilling new critical voice, offering work built of deep research and deeper moral vision. In *Ethical Portraits* she examines not just art but one of the central moral questions of our time: how incarcerated people are seen,

in every sense, by our societies. This is critical work at its most vital, addressing how art shapes how and what we see, and how this seeing can impact millions of lives.

Contents

For those who want to be seen otherwise

When we consider the ordinary ways that we think about humanization and dehumanization, we find the assumption that those who gain representation, especially self-representation, have a better chance of being humanized, and those who have no chance to represent themselves run a greater risk of being treated as less than human, regarded as less than human, or indeed, not regarded at all.

Judith Butler

Foreword by Jackie Wang

How does the prison structure the process of looking? How can we create an ethics of looking given the paradoxical nature of representations of people ensnared in the criminal legal system? These are just a few of the questions Hatty Nestor takes up in her illuminating book *Ethical Portraits*. In the representational field, prisoners are at once hyper-present and absent, sometimes made transparent for the sensationalist pleasure of the viewer, at other times consigned to invisibility to assuage the public's conscience. When they appear, their images are usually used by state actors and the media to bolster confidence in the state as the guarantor of safety and the arbiter of justice. The accused are visually defined by their depictions in mugshots, CCTV camera footage, and forensic sketches. These images are intended to confer guilt on the accused, while also propping up the legitimacy of the state. Follow them and you will learn much about the circuit of power that undergirds the prison system. Follow the skein of history and you will discover links between the contemporary genre of forensic image production and nineteenth-century methods of categorising and identifying so-called criminals by physiognomy. The mugshot itself emerges out of Alphonse Bertillon's method of using facial features to identify criminals.

Anyone who moves through public or commercial space has to contend with the non-consensual proliferation of their image in the infinity-mirror of the surveillance apparatus. Yet for non-incarcerated people, these stolen images, these surveillance portraits, exist alongside self-representations in the form of selfies, profile pics, digital avatars, and curated documentation of social gatherings. For incarcerated people, the capacity for representational agency is circumscribed by the hyper-regulated space of the prison. Self-representations are mostly limited to photos snapped in front of painted scenic backdrops during

1

visits, or selfies taken covertly on contraband cellphones.

Like colonised and enslaved subjects, prisoners have historically been looked at and visually scrutinised with great intensity, mostly for the purpose of measurement, categorisation, identification, and experimentation. Through this unidirectional gaze, images of deviance were constructed, then consolidated and circulated. This way of looking continues to haunt the visual perception of criminalised subjects. This history, when examined alongside contemporary forensic portraits, such as the suspect sketch, is a reminder that what a person sees is shaped by the place from which they look; their expectations, their histories, and where they are positioned within a complex web of power are factors that shape perception.

In the wake of this tradition of forensic objectification, as well as Susan Sontag's analysis of the violence of the photographic gaze, it would be all too easy to retreat into an anti-representational position that views all forms of representation as ethically dubious. At the very least, such a position would enable one to avoid having to grapple with the messiness of representation. Some recent works, such as Brett Story's film *The Prison In Twelve Landscapes* (2016), attempt to disrupt the ethnographic gaze by refusing to represent what happens inside prisons. Story's film seeks to make visible the ligaments of the carceral system embedded in the terrain of the US landscape by emphasising that the scourge of the prison is not limited to the interior of the prison – it eats away at all of society.

While I have found such anti-representational interventions to be a useful way to recalibrate how I see the prison system, the refusal to represent or attend to prisoners and the lives they lead while locked up also risks reinforcing the social abandonment they experience by virtue of being imprisoned. *Ethical Portraits* forces us to confront the question of whether a practice of ethical portraiture is possible when it comes to representing people who have been criminalised. How do images construct public

narratives around incarceration? How have criminalised people tried to regain control by circulating images that counter the state's representational repertoire?

On the question of whether ethical portraits are possible, Nestor argues: Yes, insofar as space is made for prisoners to appear on their own terms. Criminalised people lose most of their representational agency once locked up. The practice of ethical portraiture involves finding creative ways to enable prisoners to regain a measure of control over their images and creating platforms to circulate these counter-images. What is interesting about the way this book arrives at its conclusion is that it does so by looking at people who are looking, and by making subtle distinctions between the various modes of looking. Through interviews conducted by Nestor, with artists engaged in projects involving images of imprisoned people, the artist-observer becomes the observed.

In addition to offering a rich meditation on the process of looking, this book is clear about the stakes of representational politics. Rather than treating the issues as an abstract debate, Nestor emphasises the importance of caring for people by being responsive to their need to be seen the way they see themselves, or the way they want to be seen. As she writes, when Chelsea Manning was imprisoned at Fort Leavenworth, she was pained by the fact that the image and pronouns used by the media and the state misgendered her – pained that she was being publicly identified with a gender presentation that was out of sync with how she sees herself. Transgender and non-binary prisoners are often misgendered by the media, misgendered by gender-segregated prison facilities, misgendered in official documents, and misgendered by the public. The judicial and carceral gaze tries to render subjects legible by boxing them into normative frameworks. Manning's supporters tried to counter these logics by commissioning Alicia Neal to paint a portrait of Manning that was aligned with her chosen gender presentation.

The joy of being seen the way we want to be seen is a reminder that it is through our social entanglements that we come into being – that our capacity to experience our reality as real is bound up with collective acknowledgement. This is not a liberal politics of recognition, where a privileged subject confers humanity on a degraded subject by bearing witness to their suffering. The project of seizing control of representations, the way Manning and her supporters did, is a communal and queer refusal to be gaslit and defined by the state and media. It is part of a Gramscian war of position.

Within a liberal politics of recognition, 'legitimate' entities and persons bestow human or citizen status on abject subjects, usually by requiring subjects to conform to normative standards of behaviour and respectability. Yet given that the category of the human, in modern thought, was historically defined in opposition to racialised and criminalised subjects, adopting such a politics would limit us to the terms set by a liberal humanism, with all its Enlightenment baggage. Instead, what Nestor offers us is a politics of looking, inspired by Judith Butler's reading of Emmanuel Levinas, that asks us to encounter the face of the other so that we may become sensitised to the precariousness of life. And it is not only an ethics that asks that we look (when it would be easier to look away), but also an ethics that asks us to be open to being looked at, from across the spectral, yet all too concrete, wall that separates the free and the unfree. How do we remain entangled across that imposed divide? How do we make ourselves available to see people the way they want to be seen without assuming that they exist to be gazed at? How do we respect their right to opacity?

The stakes become clearer when Nestor introduces the element of love, in relation to Alyse Emdur's *Prison Landscapes* (2013). The project portrays prisoners, sometimes accompanied by loved ones, in front of painted backdrops depicting natural landscapes, beaches, waterfalls, and iconic monuments. Strange,

I had always been put off by these cloying backdrops when visiting my brother in prison, even as I cherished the memento I could take home with me after leaving. I felt it was cruel to dangle the fantasy of freedom in front of prisoners when their freedom has been so brutally denied. And yet I could not ignore that my brother loved these photos – he even mailed me a whole series of photos of himself posing in front of such a backdrop so I could copy them at a print shop, then send the copies to him so he could mail them to people.

What makes the photos in *Prison Landscapes* is the charged space of the visitation room – the intense love of the visitors for their incarcerated loved ones, the fugacity of the encounter, and the staging of that encounter in front of a utopian landscape unburdened by the carceral architecture hemming prisoners in – the palpability of the prisoner's desire to be elsewhere, to be free.

What are the images that can inspire this yearning towards freedom?

Introduction

There's really no such thing as the 'voiceless'. There are only the deliberately silenced, or the preferably unheard.
Arundhati Roy

How can we represent those who are not seen? When we portray someone, it is usually in order to tell the story of an individual; to show and interpret their physical attributes and characteristics. As such, portraits are a visual archive of identity and selfhood. In a traditional sense we consider the portrait to be a pictorial representation of a subject's head and shoulders, in which the face and its expression are predominant. From a young age, I found portraits alluring, perhaps because of their capacity to communicate people's characteristics, feelings, and emotions – the opportunity they offer to contemplate the visual fabric of another's life. Portraits suggest an interaction: they represent the sitter, but they also represent the perspective of the author, and have functioned as a record (both personal and historical) of status, societal position, and individual agency. If a portrait is imagined as a window into someone's character, a way of conveying their identity or relationship to and through a particular social body, what happens when this representation is unethical, obscured, or denied?

In contemporary society, access to and control over visibility are issues of hegemony. Whose stories are told, whose faces are seen, and how they are portrayed is dependent upon signifiers such as class, race, and gender conformity. But what about the portraits of those without access or power, in prisons and the criminal justice system? Or the infinitely generated images produced by mass surveillance technology to which we all are subjected? These portraits are not necessarily chosen by those they depict, yet so often they become normalised, unquestioned,

and in some cases violent illustrations of marginalisation.

Mug shots, e-fits, pro-fit systems, facial recognition technology, surveillance, and courtroom sketches of defendants tend to extend very limited agency to a subject when determining their image. The publicly circulated portrait of the individual summoned to a criminal trial is often taken from CCTV footage – a form of surveillance that has little interest in the will of the person being recorded. This is also true of the portraits the criminal justice system commissions of people either on trial or post-conviction. In writing this book, it was my intention to investigate portraits produced within the US criminal justice system, a country that incarcerates its citizens – through blatant racism – more than any other in the world, and the constraints and circumstances that impact upon their creation. I also wanted to examine those portraits which aim to subvert the subjugating tendencies of that criminal justice system. This book seeks to uncover the power struggles that dominate one person's depiction of another's identity, and to address broader ethical questions of visibility, accountability, and recognition. To what degree is an image of that life produced, preserved, recorded, and archived? Who is and who is not considered worthy of representation, and for whose consumption are such images made?

As a society we are presented with mugshots on television, wanted posters, courtroom sketches, and the media's use of portraits of defendants (and the convicted), all of which raise questions concerning the ethical and dialectical relationships we engage in, both as consumers of images and as subjects in them. It is my contention that when documenting someone else, the artist inherently enters into a position of accountability and responsibility. Or, as in the ethical philosophy of Emmanuel Levinas, it is a moment when a moral obligation to others, by default, should take priority over the so-called individual self. Over the following chapters I confront questions concerning

images of prisoners, with the intention of opening up discussions as to where and when representation of 'criminals' is called for, and how and why we might grieve – for example in instances of missing persons, murder victims, and executed prisoners.

When a life is grieved, it's because that life has, in some regard, been deemed worthy of representation and remembering. Think of all the lives which end without recognition, in war, in the migrant crisis, and other modes of violence and conflict; think of those whose statuses remain unresolved, unseen. In a similar vein, I explore the circumstances in which we are able to relate or respond to another's incarceration. It is the ethics of this interrelation – between dead and living, inside and outside, free and captive – which I want to question, particularly when considering how the 'I' and the 'me', and the 'who' and the 'they' are constructed within the criminal justice system; a structure which explicitly misrepresents and dehumanises those it imprisons, detains, and puts on trial. As such, the tangled thread of grievability reappears throughout this book, as a kind of haunting.

My pursuit of what representational justice might, or indeed could, look like in the US is intrinsically linked to the different contexts in which portraits are created inside and outside prison. Unlike the proliferation of 'selfies', the portraits discussed in this book are produced in a climate of scarcity and constraint, where images are often difficult to produce or are strictly off-limits except to those operating on behalf of the state. Prisons, courtrooms, zones of solitary confinement, and spaces with heightened law enforcement all impose material and physical restrictions, making the production of portraits based upon direct encounters with a subject difficult for all but officially sanctioned artists.

For artists on the 'outside' – that is, those not directly subjugated by the criminal justice system – depicting individuals in prison means that at times there is a fictional element at play in their

work. They are required to imagine not only how the individual might wish to be represented, but also the varying functions of the portrait when shown to the public. The widely circulated 2014 portrait of Chelsea Manning, for instance, was commissioned by the Chelsea Manning Support Network while Manning was in prison for 'leaking' US Army documents. Intended as a form of visual activism, it was created in response to her transgender status and, at the time, the authority's refusal to allow Manning to determine her gender by continuing to use an image depicting her as male. The portrait produced by the Chelsea Manning Support Network is the focus of the first chapter. Another portrait of Manning was later produced by the artist Heather Dewey-Hagborg, in a similar vein to those made by forensic sketch artists who undertake the task of piecing together the image of people whose faces or bodies are no longer physically visible. The history, and current use of forensic art, is explored in chapter six. The work of Dean Spade, a lawyer, writer, and activist and founder of The Sylvia Rivera Law Project, has been of momentous importance to my research into the representation of transgender prisoners. Essays such as *Documenting Gender* (2008) and Notes Toward Racial and Gender Justice Ally Practice in Legal Academia (2012) unpack the legal implications of gender and LGBTQIA+ rights in the US, and the visibility of trans politics within the prison-industrial complex and competing judicial frameworks. The lack of treatment is perpetual and fails transgender prisoners nationwide in terms of reclassification and reassignment procedures. I also encourage any reader who is interested in the intersection of law, gender, and neoliberalism to read Spade's fierce book Normal Life: Administrative Violence, Critical Trans Politics and the Limits of Law (2015). But what can art tell us about relating to others? In general, representations of prisoners produced by the criminal justice system and the media are not conducive to radical re-imaginings and liberation strategies. Yet a recent trend within contemporary

art has seen artists concerning themselves with detainees, in an attempt to reflect upon the prison-industrial complex as a whole. The detention room, the prison cell, police custody, and the courtroom are all 'settings' that by their very nature strip the accused or convicted subject of control over their identity and agency. These investigations have taken the form of both commercial and personal projects, with institutional backing and support from those who express concerns about the representation and vulnerability of marginalised individuals. In England, in 2016, I visited Artangel's project *Inside: Artists and Writers in Reading Prison*, an exhibition that highlighted the criminalisation and detention of Oscar Wilde in 1895 for homosexuality. Famous artists, writers, and public figures were invited to recite sections of *De Profundis* (1905) – a letter written by Wilde from prison to his former lover Lord Alfred Douglas and published after his death – as part of a series of readings and tours.

After experiencing the project, it felt plausible that a contemplation of Wilde's suffering might influence public perception and opinion about those in detention today. Yet I went away asking: what purpose is served in the current political climate by exhibiting the work of famous artists in an abandoned prison? Does using celebrity criminality serve as an active tool for questioning the current representation of prisoners? I left Reading Prison feeling that the exhibition lacked any sense of incarceration as a lived, visceral reality.

Despite the potential pitfalls, we shouldn't underplay art's ability to harbour new possibilities of representation. Whether an outcry, a tool for expression, or a collective act, each artistic endeavour has the potential to affect the onlooker. Over the last few years I have observed different kinds of 'prison art', including that which is created by prisoners, and in turn takes the prisoner as its subject, as well as activist art. In the project *Captured* (2016), for example, discussed in chapter four, two

activists, Andrew Tider and Jeff Greenspan, contacted current prisoners to portray those they felt should be in their place, such as bankers and the CEOs of large corporations. For artist Alyse Emdur's project *Prison Landscapes* (2012), explored in chapter five, prisoners in low security jails in the US pose for portraits in front of painted backdrops designed by the prisoners themselves. Fantasies of freedom, scenes of sprawling utopian beaches, national monuments, and even the Grand Canyon, function as a momentary escape. Both *Captured* and *Prison Landscapes* are attempts at what might be called aesthetic justice: a type of self-representation that pushes back against the visual identities allocated to prisoners by the state, humanising its subjects, calling into question the very nature of criminality, and using artistic and performative language as a tool for reimagining.

This book was written in the UK and New Mexico, the two places I grew up. In a sense it began in my childhood, long before my own understanding of the politics of incarceration, representation, and institutionalisation had developed. The department of corrections in New Mexico is 24 miles below Albuquerque on interstate 25, a city well-known for its high crime rates that featured in the neo-western television drama *Breaking Bad* (2008).[1] The American West has a reputation for individualistic freedom, and the landscape holds a clear message: tread carefully, beware. I was also influenced by having a family member with mental illnesses, who spent time in and out of psychiatric hospitals, and growing up on a council estate, where I watched the people around me become a byproduct of their conditioning and having little opportunity to do otherwise. I had my own complicated experiences of not seeing 'law and order' implemented in young adolescence, too. Later, I spent time with peers who lived in YMCAs or ended up in prison for committing violent acts as a result of their abusive home lives. I didn't know then about the political and economic context to which these events belonged, but I had a strong intuition that

the situation extended beyond the individuals in question.

In order to get as close as possible to my subject matter, and in an attempt to avoid the perils of well-meaning historicisation and romanticisation of the figure of the criminal, I decided to base my research around conversations with artists making portraits of incarcerated, missing, and wanted people today. It is my hope that these interviews ask important questions about the experiences of prisoners in the present, rather than reevaluate historical crimes. From the beginning, I intended this book to function as an oral history project – interviewing artists as a way of interrogating the kinds of portraits produced within the criminal justice system, while also investigating how my own writing operates as a portrait of my interviewees. The interview as a genre of writing has long functioned as a way of retelling stories and generating representation. By no means is this book an attempt to speak for prisoners. Instead, by considering the images produced by the interviewed artists, I intend to prompt people to question their own ethical, emotional, and political stance.

Letters, like interviews, can also be a form of political activism and a point of connection between inside and out. Prison abolition groups, such as the grassroots organisations Black & Pink in the US and Bent Bars in the UK, were founded to function as letter-writing platforms for imprisoned members of the LGBTQIA+ community. Black & Pink recently invited prisoners to send their portraits to be exhibited at Abrons Art Center in New York. Images of Barack Obama, Rihanna, and fantasy fairy characters covered the walls, and visitors were presented with a window into the creative life of those living in prison. If we can move towards a collective mindset where prisoners are considered as authors, maybe perceptions of those on the inside can also be revised. Perhaps sharing, reimagining, and discussing these practices can create a new visual link to prisoner experience, challenging the general public's perception

of the incarcerated subject in the process.

Before many individuals caught up in the legal system have a chance to consider how they wish to be represented, their portrait is officially produced in the form of a courtroom artist's sketch. Courtroom artists are first and foremost illustrators: they document live trials. In the UK, their sketches are sold to media outlets in cases where photography and filming is prohibited. These artists take on the responsibility of depicting the unique narrative of each individual who stands on trial, and as such the illustrations they produce require certain questions to be asked of them. How are individuals given agency when their representation is constituted by someone else, so quickly – indeed, the word 'sketch' is telling – and at an impersonal distance? Do they meet their sitters? Are any words uttered between the two parties? In chapter three I explore this dated and strange form of documentation, asking whether and why it is necessary within the criminal justice system, and who it ultimately benefits.

During the last few years I have been in touch with several inmates in various US jails, supermax prisons, and detention centres. While writing and researching for this book, I have considered what it might mean to belong, retain agency, reconstruct identity (or indeed if this is even necessary), and to create solidarity through the visual image. These, to me, are urgent thoughts to be thinking, particularly when one begins to understand how the architectural environment and internal structure of the prison arranges and isolates inmates – not only psychologically and emotionally but also literally in very physical ways. My interactions with inmates were a profound insight into the violence of walls, and how an artist, whether incarcerated or otherwise, can help provide agency for inmates. I don't believe that I can speak for those who are oppressed and marginalised, but I can use my position as a writer to question injustice, and to ask: who has a right to representation on their

own terms, and for whom is this right obscured or denied? This, I hope, is where consciousness raising begins.

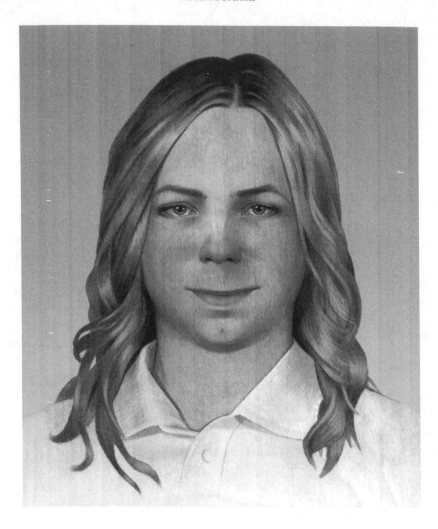

'Final Painting' (2014) 8'x10', Acrylic on birch plywood and digital.
Courtesy of Alicia Neal

Facing Future Feelings: The Portrait of Chelsea Manning

To recognise transgender capacity is not to equate all episodes of potential but rather to allow the recognition of their particularity and to resist the normative presumptions that have enforced their invisibility.
Susan Stryker and Talia Mae Bettcher

Last autumn I listened to an episode from the 1999 'Lock Up' series of This American Life, which explored the way prisoners represent their identities visually once they have been released. During the podcast, an ex-detainee explained that during incarceration they 'had very little to see or look at, in terms of variety, in terms of what one had become used to. Seeing people come and go, different distances, different colours, different lives, all just one vague, big, grey soup.' What struck me about his comment was how starkly prison-industrial complexes violate the agency of those they detain, limiting the ability of prisoners to connect with each other and the outside world, and most of all, denying any expression of individual identity. I began to wonder: what would an ethical portrait of a prisoner look like? Can art be used as a tool to give agency back to those on the inside? Or rather, who do prisoners rely on to construct images of them from the outside? I started to think of Chelsea Manning – whose high-profile case made particularly poignant the importance of retaining the visual integrity of prisoners, in the face of a system which seeks to siphon off all humanity.

Some days after listening, I found myself returning to the same question. Can art create an accurate, ethical visual representation in instances where prisoners are otherwise dehumanised? I began to consider how writing and visual art as a socially engaged activity can help us to investigate the representation of

prisoners deemed invisible by wider society. Historically, and in the present, I've come to understand that the prison-industrial complex fractures the agency of those it detains, through making them invisible to the outside world, limiting connectivity and, most of all, denying them the possibility of self-assertion. This violence is yet more apparent when we consider the identities of transgender prisoners, whose representation in society is already severely limited.

The dehumanisation of transgender prisoners is by no means unfamiliar, but the trial, prosecution, and release of Manning has shifted the rhetoric of both media and personal representation into a different realm. During her incarceration I knew of Manning as someone both famous and infamous, whose identity as a trans woman and committer of treason had been widely sensationalised. A United States Army soldier, Manning was convicted under the Espionage Act and for a number of other offences in 2013, after she 'leaked' over 700,000 sensitive diplomatic documents to the secret sharing site WikiLeaks. The files contained war logs from Afghanistan and Iraq, diplomatic cables from the state department, and documents referring to Guantanamo Bay. After pleading guilty to ten of the 22 charges she was accused of, Manning was sentenced to 35 years' imprisonment at Fort Leavenworth, Kansas. Prior to sentencing, she also spent 3 years in detention centres such as Camp Arifjan in Kuwait, as well as prisons in Virginia and Maryland. In Fort Leavenworth, Manning was held for 23-hours-a-day in solitary confinement with no sunlight.

As Manning's case unfolded, I kept many jottings, notes, and screenshots of news reports. What grips me about her case is the complexity of its legality in relation to war and surveillance, intensified by the complex ethical questions produced by her gender transition. Who was this woman, who appeared to be so integral to, yet so mistreated by the state? What was going on during her incarceration that the public couldn't see? In

the margins of a printed out TIME article from 2015 entitled 'Chelsea Manning Can No Longer Be Called "He" by the Military, Court Rules', I wrote: 'How does the prison-industrial complex monitor, represent, and treat transgender inmates?' A simple question, but I soon discovered that the attention given to Manning's case was symptomatic of the widespread violence of the US justice system.

Transgender inmates can arouse confusion and rage in the prison-industrial complex and society at large, making them more vulnerable to mistreatment and violence. They are sanctioned, ignored, and deemed unworthy of protection. Before 1830, the US penal system wasn't segregated by gender, yet throughout my research I found that it is still usual for transgender inmates to be admitted to an incorrectly gendered prison. In the US, the vast majority of incarcerated transgender women are housed in male facilities and denied hormone treatment. Activist group Black & Pink's 2015 national LGBTQ prisoner survey 'Coming Out of Concrete Closets' reported that '23 percent of transgender, non-binary gender, and Two-Spirit respondents are currently taking hormones in prison, while an overwhelming 44 per cent report being denied access to hormones they requested.'[1] Manning was refused hormone treatment, rejected for psychological help, and relentlessly placed in solitary confinement as a penal strategy. Her detention – isolation and torture – is the story of many; it is by no means exceptional.

These horrifying statistics affirm the structural transphobia within the penal system. Even in 1979, The International Gender Dysphoria Association acknowledged that 'housing for transgendered prisoners should take into account their transition status and their personal safety'.[2] Yet the state continues to organise transgender and gender nonconforming prisoners in a manner that furthers their marginalisation. In the essay 'Caging Deviance' in *Queer (In)Justice: The Criminalization Of LGBT People In The United States*, (2011) collectively written by Joey Mogul L,

Andrew J Ritchie, and Kay Whitlock, they discuss the violence of gendered incarceration and segregation. 'Not only have prisons failed to deter crime and produce safety,' they write, 'they are sites where the safety, dignity, and integrity of all prisoners, including LGBT prisoners, are eviscerated.'[3] Given the hostile conditions, it felt crucial to consider how empathy with inmates could materialise as visual art. In retrospect, collecting these articles was a way for me to re-appropriate news reports – to uncover alternative narratives surrounding Manning's case, avenues through which to interpret her mistreatment. I read between the lines in a bid to understand what might be absent, and how the reports might be generating visibility – to build a picture of if and how the factual elements of her story were being put to use. Two headlines are potent examples: the Thinkprogress article (2015), 'Growing Out Her Hair Endangers Chelsea Manning's safety, Feds Argue'; and The Atlantic article (2016) 'Chelsea Manning's Suicide Attempt', which bluntly reports her psychological distress. Both, in a roundabout way, suggest three things: the seriousness of Manning's situation, the legal restrictions and perversions placed upon her gender identity, and the press's willingness to capitalise upon it. The headlines were painful reminders of Manning's suffering. What would have happened if Manning's sentence hadn't been commuted by Barack Obama in 2017? How much longer would she have been kept in solitary confinement? And how many others are still being kept there?

Prison, solitary confinement, and detention are all imposed in order to sanction, isolate, and divide. The rise in supermax prisons since the 1980s – originating in Arizona and California and accelerated by the presidency of Bill Clinton – has amplified the prosecution and punishment of those deemed delinquent by society. A particularly harrowing example is 'Tent City', an outdoor prison in Phoenix, Arizona, opened by Maricopa County sheriff Joe Arpaio in 1993, and finally closed in 2017. Tent

City was a fully functioning concentration camp, and Arpaio openly referred to it as such at campaign rallies. 'I already have a concentration camp, it's called Tent City,' he announced to his political supporters in a local Italian-American club, in a terrifying speech which can still be accessed via YouTube. The prison was advertised as an alternative to serving longer sentences. Inmates were told that if they submitted themselves to living in temperatures as high as 120 degrees Fahrenheit they could have days shaved off their sentence: a capacity-enhancing solution for 'doing time'. It is very difficult to gain access to supermax prisons, and consequently I have never visited one, though I have exchanged letters via Jmail, an online service for writing electronic messages to prisoners, with a woman who was incarcerated in Pelican Bay State Prison, Crescent City California, who for the purposes of this anecdote I will refer to as B. In her letters she described her experience of being kept in permanent or semi-permanent solitary confinement. B explained that in supermax prisons, state violence and psychological damage are often perpetually exacerbated by government authorities.

<p style="text-align:center">*</p>

In 2010, 3 years before her incarceration and a month before her arrest, Manning attached a black-and-white photograph in an email to retired Master Sergeant Paul Adkins (her supervisor at the time), with the subject line 'My Problem'.[4] The photograph, which has since been widely circulated, shows Manning in a car seat wearing a blonde wig and make-up, and is often considered her first attempt at asserting her gender identity. Photograph and email, both of which were originally intended as a private plea for help to a senior member of staff, came to public attention during Manning's court martial in 2013. Her lawyers rightly questioned why Adkins had apparently done nothing to support a vulnerable employee after she had directly reached out to him.

According to a court reporter, the email reportedly contained the line: 'I don't know what to do anymore, and the only "help" that seems to be available is severe punishment and/or getting rid of me.'[5] When Manning was trapped in solitary confinement after a suicide attempt, The Chelsea Manning Support Network released a statement on Manning's behalf expressing a similar sentiment: 'I need help. I am not getting any. I have asked for help time and time again for 6 years and through five separate confinement locations.' Following the release of such viscerally charged material, and after entering a week-long hunger strike in protest against being denied treatment during her detention, Manning was permitted sex reassignment surgery in September 2016.

Before her hunger strike, Manning's representation in the media was limited to images that misgendered her, and those that were not intended for widespread distribution. Because of this, in addition to releasing statements on her behalf, The Chelsea Manning Support Network decided to commission a new portrait of her – one that would better reflect who she was and how she wanted to be seen. Under US Army Regulation 190–47, prisoners 'will not be photographed, except in support of medical documentation and for facial identification purposes'. As Manning could not sit for a portrait in prison, there needed to be alternative artistic avenues to mitigate what the Support Network saw as the visual mistreatment of her in the media, and to allow Manning to take control of her image from inside Fort Leavenworth. The Support Network approached Alicia Neal, an artist and illustrator from Philadelphia with no prior experience of depicting prisoners, to create an image that could be utilised across media outlets as Manning's 'official' portrait.

When I came across Neal's website, her practice appeared kitsch and enigmatic, often finding its subject matter in folklore and paganism. At first glance she seemed like an odd choice, and I was curious to know why the Support Network had chosen

to contact her specifically. Following a call out on behalf of the Support Network, Manning was sent a handful of drawings from illustrators recommended through friends in prison. After much consideration, and looking over several different candidates, Neal made the cut. I read that she had had to work from Manning's official military portrait, sending drawings to Fort Leavenworth, waiting for a response which came via the Support Network, and redrawing accordingly. I came to understand that every aspect of the image's production had involved considerable ethical and political considerations – from the intention behind the commissioning process, finding a way to produce a suitable representation despite the limitations of image production imposed by prison. I hoped Neal's portrait could reimagine Manning and offer an alternative to the other images circulated by the media. Perhaps it could be an example of ethical portraiture?

I soon realised that Neal's portrait could only be ethical if its pursuit was a realistic representation of Manning. But how was this possible, when she was unable to see Manning in the flesh? The idea of a caricature or impressionistic portrait seemed to defeat the purpose of reinstating agency for someone who had so emphatically been denied it – yet there is sincerity to Neal's work, which serves as the presence of someone who cannot be heard. It often featured on placards used at the Occupy protests across the US, as a rejection of the manner in which Manning was represented by neoconservative news outlets, who continued to misgender her by using photographs of Bradley. Neal sought to preserve and reimagine Manning as human, and not a subject defined by rule and law. Her portrait is not just the face of a woman who needed an alternative representation: it is also the portrait of a society which misrepresents, and refuses to acknowledge, individuals who do not conform to its aggressively narrow expectations.

I knew I could only confront the intricacies of the portrait by

speaking directly to Alicia Neal. I wanted to hear how Manning came to trust her; about the dynamics of their intangible relationship. I wanted to know under what conditions the portrait emerged, and who it challenged. Neal promptly replied to my first email, in December 2016, proposing an interview: 'I am happy to help. I'd like to mention first and foremost that I've never had direct contact with Chelsea.' She told me that her correspondences with Manning had been conducted through the Support Network, and that the two had never had direct contact. We arranged to talk a week later.

*

I have come to understand an 'ethical portrait' to be a depiction of someone which holds political weight, is integral and empathetic, which challenges marginalisation through a visual image. Mugshots, in contrast, are a protocol of the justice system's implementation of discipline. They are the least merciful representation of prisoners, which demand their subjects to act as if they are already corpses, staring into the camera with morose expressions, wearing the uniform orange jumpsuits which signal their new societal status.[6] Although Neal's portrait of Manning does not intend to mimic a mugshot, it does focus on the face and shoulders, displaying some similarities to traditional portraiture and police photographs. Overall I considered it positive to produce an alternative mugshot of Manning – one which could replace the legally sanctioned image, as part of an activist push to recognise her gender. Yet viewing the image I am also cautious that the mugshot – as a historically criminal mode of documentation – perhaps runs too close to an always-already oppressive kind of image making. Neal explained that Manning's mugshot, if one existed, was never used in the media, which instead tended to illustrate articles with an 'official military portrait of Bradley'; but, she says, it switched to the

'selfie once she declared that she was transitioning, because there was no other option'. That 'no other option' is imperative here. Neal was keen to explain that the black-and-white selfie, intended for the eyes of her superior officer, ended up being 'circulated like a mug shot', which was 'very damaging to her image'.

In 2013, while still in Fort Leavenworth, Manning made a statement to NBC's Today show. 'As I transition into this next phase of my life,' it read, 'I want everyone to know the real me. I am Chelsea Manning. I am a female.' The release of this statement allowed Manning to assert her gender identity on her own terms – a project to which the Support Network were keen to contribute. By engaging Neal, they wanted to provide Manning with a portrait she would feel comfortable with, an illustration she liked, and, crucially, one intended for public circulation.

Neal presents Manning as calm, composed, and comfortable in her expression and gender, with what Neal describes as a slight 'Mona Lisa smile'. The background is neutral, as is her expression, and her shirt – the image composed as if to say, 'I am here, and this is me.' It became increasingly apparent that Neal's intention was to put Manning's desired representation first, ahead of her own creative agency as an artist. She was keen to define the ways in which this portrait differed from her usual mode of working, as it had to be constructed from existing drawings and interpretations of her subject. 'Normally when I do portraiture I like to be able to take my own photos and talk with the subject,' she said. 'It was really difficult trying to communicate because we weren't allowed to speak over the phone.'[7] She also told me that her, 'main focus was giving her the dignity of at least being seen as who she wants to be, trying to keep it to basically what I thought she would look like realistically, and not like this fantasy character'.[8] 'I'm not a very political person,' said Neal, 'but I support Chelsea as a trans person, so I feel like this is sort of my contribution.'

Neal told me that many people have speculated on whether Manning received 'special treatment' as a political prisoner, being allowed to write for major news outlets, undergo gender transition surgery, and have a portrait made. 'Other prisoners don't get to write articles for Huffington Post and the Washington Post,' she paraphrased, and:

> they certainly wouldn't be allowed gender transition surgery. Taxpayers don't want to have to pay for someone who is incarcerated. There has been a lot of outrage over the fact that she was allowed to have a portrait made. Which wasn't the case, it's not like she requested it from the government and was granted it; it was an outside party that gifted it to her.[9]

When it comes to arguments over whether Manning received preferential treatment, it is important to remember that in 2016, when I interviewed Neal, Manning was still detained in Fort Leavenworth with no future discussion of release, and subject to another 28 years of imprisonment. Release was a hypothetical future imagined by the Chelsea Manning Support Network. Back then, Manning was removed from society, defined and represented by the institutions in which she was incarcerated: it is hard to see her as the recipient of special favours or privileges. Manning wrote about the state of non-being in which she was held in an article for *The Guardian* published in December 2015 (her sixth Christmas in prison), a newspaper she regularly contributed to from within Fort Leavenworth. 'Living in a society that says "Pics or it didn't happen", I wonder if I happened. I sometimes feel less than empty; I feel nonexistent.' I am particularly interested in how restrictions on communication, imposed by prisons, impact upon the ways in which an inmate may assert their identity and exercise agency over their visibility. Prisoners are limited to communicating with the outside via paid outlets: Jmail, Corrlinks, Jpay, handwritten letters, and phone

calls. Some prisons have also introduced HomeWAV, a video chat service similar to Skype or FaceTime. These chats often only last 15 minutes and are regulated by prison authorities. When the story broke that Manning had been placed in solitary confinement following her suicide attempt in 2016, the news horrified activists. Once in solitary confinement, it was reported that she had all of the above-mentioned communication methods suspended, and that even her usual scheduled phone calls to the outside world had ceased. Such inhumane circumstances can have devastating effects on inmates. In an article for The Guardian in May 2016, Manning described being confined in a 6 x 8 foot cell: I 'was not allowed to lay down. I was not allowed to lean my back against the cell wall. I was not allowed to exercise.'[10] Such an environment only furthers isolation and deepens identity issues, making the connection between Manning's representation and the outside world all the more urgent to consider.

I came to interpret Neal's portrait as a gesture of empathy transformed into an event of justice, a visual representation of Manning's existential worth. Manning, Neal suggests, has 'been demonised left and right, and I think it's hard for people to see her as a person'. She wanted to make the portrait:

> as serious and conservative as possible so that she would be taken seriously. I wanted to give her the dignity of at least being seen as who she wants to be, because I have trans friends and I've seen them go through the transition and how hard it can be to represent yourself and make people see you as you.

Her work reimagines Manning sympathetically as a political prisoner, and liberates her image from a punitive construct. When the portrait was released on the Chelsea Manning Support Network website in May 2014, there was a sudden shift in the attitudes of the press, as the new image replaced the military

photograph; Manning's suffering in relation to her gender identity was no longer hypothetical, but newly validated. Several headlines from 2014, following the portrait's release, marked the transformation in attending to Manning's representation and wellbeing. A headline from a *FAIR* article in 2014 asked 'Chelsea Manning speaks – But who listens?'; a *Popular Resistance* headline noted 'How Chelsea Manning sees Herself'; while *The Verge* offered 'Meet Chelsea Manning's official portrait artist'. These all extended Manning's identity – or need for a reconsideration of it – in the public domain.

Neal's portrait is a reminder that Manning's identity has nothing to do with her imprisonment. It reminds us that we are not solely defined by the institutions and environments we are subjected to and conditioned by, that we do not have to stand for the myriad ways in which society is numb to those who are marginalised. My conversations with Neal showed me that images – in contradictory and unprecedented ways – can be actions and social commentaries.

A great relief swept over me when Obama granted Manning's clemency on 17 January 2017. Manning was no longer a detainee staring at decades in prison, but a political prisoner who has been reconsidered as human. Yet it feels important to remember that while Manning's clemency may on a political level appear as a form of justice (which, of course, it is), the sudden move from prison to the outside world doesn't undo feelings entrenched during incarceration. The difficulty of adjusting to out-of-prison-life, and adapting to publicity and visibility, are just two examples of how the psychological effects of imprisonment extend beyond the cell walls.

Before Manning's release, a Google search for images of her returned three Mannings: the army photograph from before her transition; the grainy, bewigged, monochrome selfie; and Neal's portrait. After her release was announced for 17 May 2017, a steady stream of new public images began to circulate. First, an

Instagram shot of her two feet with the tagline 'First steps of freedom!! :D', followed, a few hours later, by a slice of pizza. Her Instagram – xychelsea87 – operates as a space for humour and self-expression. On Twitter, Manning's use of emoji became an idiosyncratic appraisal of Trump's presidency. A recurring tweet reading, 'We have more power than they do' and, '#WeGotThis' is perhaps the most optimistic example of the way she has been able to employ social media as a tool to reclaim the voice she was denied in prison. 'I could not go on living in the wrong body,' she explained in her first video interview with ABC News in May 2017. 'I used to get these feelings where I just wanted to rip my body apart.' Despite these horrifying, visceral words, I felt warmed seeing her speak on national news, embodying the freedom Neal's portrait sought to create.

Neal's portrait envisioned a future, and her willingness to embrace Manning's position is intrinsically bound to a shared position of hope – one that transcends prison walls and physical barriers. Much like a shared encounter that goes unsaid and leaves an emotional mark, the portrait is an experiential site of solidarity and compassion, a physical affirmation of bonds that exceed materiality. It meditates upon the complex territory of incomprehensible dehumanisation, while rendering a visual act of artistic justice, a window into how we can change the lives of others, if only momentarily, through imagery. Her portrait attempts – through medium, form, context, and content – to fundamentally change the meaning of what art can do in society.

The opulent photograph of Manning published on her Twitter and Instagram accounts @xychelsea87, 3 days after her release on 17 January 2017 – where she peers into the camera sideways, dressed in a black and slightly unzipped jacket – is perhaps the most stoic of her current public portraits. It is no longer a substitute for her experience – it is her lived experience. Here, her expression is quietly confident, her posture astute, her clothes and make-up slick. Today, Manning's face is everywhere.

Not as an illusion or representation, but simply as the face of a woman becoming increasingly familiar and admired by society.

This chapter was written between 2017 and 2018. In 2019, Chelsea Manning was readmitted to solitary confinement, having been imprisoned for refusing to testify before a grand jury investigating WikiLeaks.

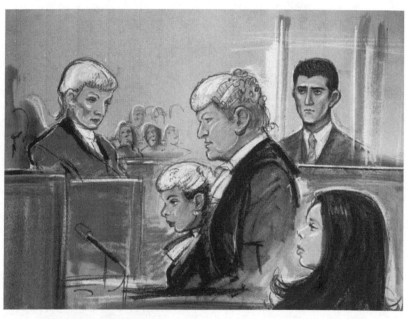

Priscilla Coleman, 'Cardiff Crown Court Footballer' (2015).
Courtesy of Priscilla Coleman

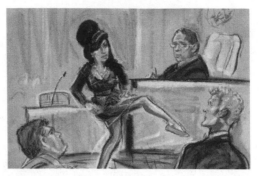

Priscilla Coleman 'Amy Winehouse' (2013).
Courtesy of Priscilla Coleman

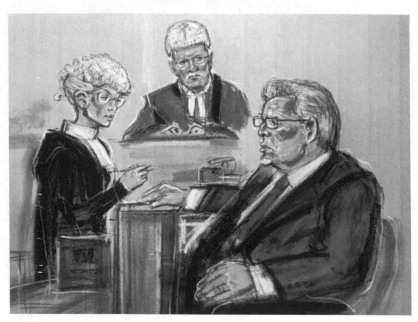

Priscilla Coleman, 'Rolf Harris' (2016).
Courtesy of Priscilla Coleman

Negotiating Empathy: Courtroom Artists

Society loves courtroom dramas – they allow the viewer to consume the uncertainty of someone else's life as opposed to fixating on their own. (I am as guilty of this as anyone: I've watched courtroom dramas every week religiously in the past, especially Primal Fear and the Lincoln Lawyer.) We get hooked on the interrelations of characters, the impending catastrophe, the emotional mind games played by the press, lawyers, and bogeymen criminals. The allure of the genre, I believe, has to do with the hidden nature of the legal scenario. Films, television shows, and podcasts purport to expose the mystery of the courtroom, and the private lives of those tangled up in its web.

Beyond courtroom dramas and 'true crime' stories of trials, such as Dateline, American Crime Story, Killing Fields, and my recent favourite, Netflix's The Staircase, the courtroom sketch is a key example of how the goings on at trial are represented and disseminated.[1] Notable cases that have been illustrated include Amy Winehouse's 2009 trial for assault after she was accused of hitting a woman at a charity ball. A drawing by sketch artist Priscilla Coleman shows Winehouse extending her leg and hitching up her dress, in order to demonstrate to the court her slight frame as evidence of her innocence. In contrast, the mood of Coleman's drawings of Rolf Harris during his 2014 trial for indecent assault is distinctly stern. In the background of one sketch, two members of the jury place their hands over their faces – presumably in light of an unwanted verdict. All of the figures surrounding Harris are vividly animated, yet he sits slumped and despondent, facing the judge as if his fate has overwhelmed him. Shortly after the verdict, Coleman tweeted: '#rolfharris guilty. I think we probably guessed that.' TV news coverage of the trial followed the release of Coleman's sketches. The Independent reported that Harris 'show[ed] no remorse'

during the trial – a depiction shaped by Coleman's interpretation of Harris's behaviour in the courtroom.

Taylor Swift's courtroom portrait is among the most humorous I have encountered. After Swift filed a lawsuit against ex-DJ David Mueller for groping her, a sketch by Jeff Kandyba became a subject of public debate – especially on social media. On Twitter one fan wrote, 'Why does the @taylorswift13 courtroom sketch look like #OwenWilson?' Swift appears older, her stance slightly hunched: more dinner lady than pop star. The background is coloured orange and her expression is pensive and aged. (In his defence, Kandyba claimed 'she was difficult to draw because she was too pretty'.)[2] Jane Rosenberg faced a similar backlash for her portrayal of quarterback Tom Brady in 2015, which was heavily scrutinised by the press. *USA Today* reported 'it looks like Brady's face was put in one of those machines that crushes cars'[3]; *CNB News* said he looked like Lurch from The Addams Family, or E.T. (In reality, the sketch wasn't so bad – I've seen people pull similar faces on drugs.)

During my research, it became apparent that there is a lack of critical reflection on this genre of portraiture and legal modes of sketching trials. The courtroom is where accused citizens stand before a judge, cases are heard, and the verdict is returned to the subject. It is where families, victims, press, public, and police sit together and await the verdict of the jury. It is a place where lives change in an instant, where the agency of the individual is suspended and placed into the hands of the state. These strange and sometimes spectacular sketches appear in the media after the trial, presenting complicated questions of representation, agency, and empathy. Who draws the images in the closed space of the courtroom, and for what purpose? Do the drawings they produce seek to reflect the experiences of the people captured in their sketches – or do they have another agenda?

In the UK, where photography is almost entirely banned inside the courtroom, artists draw from memory after the trial.

Following this, they sell their illustrations to media outlets. 'These deadlines are hideous,' explained artist Christine Cornell to the BBC in 2017, describing the time pressures those in her profession face: when 'the hearing's over is when they want the drawing'. Because the sketches are drawn from memory, it is the practice of many courtroom artists to take written notes of the scene they are observing. For example the artist Julia Quenzler told the BBC that she 'writes brief notes to herself about the hair, facial features, clothing and body language of the main players' to then translate into a visual image after the hearing.[4]

Courtroom sketches are legally sanctioned media representations of trial proceedings – their production bound to the media and court's demand for documentation. With regards to this art form, I've come to understand that visibility doesn't necessarily mean retaining agency over one's appearance. Some forms of visibility can actually be alienating when the representation is inauthentic to reality, or contravenes the wishes of the individual. 'Nobody's there to pose for you,' William Hennessy Jr told the BBC in 2017, a courtroom artist who has sketched Mike Tyson, Chelsea Manning, and Paul Manafort. 'You want to think journalistically, you're providing a visual story.'[5] By this measure, the work of an artist like Hennessy Jr lies somewhere between producing documentation and creating marketable, eye-catching material.

In today's society it seems anachronistic that we often still rely on sketches made after the fact. (That an artist can take written notes in court also raises the question: why can't they draw?) In the US, as of 2014, all 50 states permitted photography in the courtroom, rendering the sketch artist obsolete. Yet the fact that the courtroom sketch is still extant in many countries is evidence of ambivalent attitudes towards the application and efficacy of technology. Why use sketches, after all, when you could take photographs or produce film? As the trial of OJ Simpson demonstrated, photography in the courtroom can be

as much of a problem as it is a solution. Simpson's trial was one of the most controversial in the last 25 years – *USA Today* called it the 'the most publicised criminal case in recent history'.[6] In Los Angeles, 1995, Simpson was found not guilty of murdering Nicole Brown Simpson – his ex-wife – and her friend Ron Goldman. The feeling that he got away with murder – with the help of his lawyer, Johnnie Cochran, a master at acquitting the rich and famous who also represented Michael Jackson – was compounded by the fact he later admitted as much in his tawdry book *If I Did It* (2007), a tell-all confession. Simpson's trial raised debate about TV and photography in the courtroom. The judge ruled live coverage acceptable, and a media circus ensued: when the trial began on 24 January, it was televised for 134 days by network outlets. Yet despite the wide use of photography in US courtrooms since 1987, the appearance of video was unheard of at the time – and is perhaps a testament to the public fascination with the case, not to mention the financial incentive for the press. The heightened visibility caused enormous public fascination with the trial as an emotive, politically explosive soap opera – arguably to the detriment of the victims, whose stories became entangled in Simpson's audacious spectacle. Following the trial, and understandably, many judges decided to ban filming in their courts.

When it comes to matters of the courtroom, some cases are surely easier to empathise with than others. A sketch artist may have a personal connection to the plight of the accused or accuser, and certain crimes are deemed so abhorrent that to be associated with them at all can result in lasting stigma – even when the accused is found not guilty. Deep-rooted stereotypes of what a criminal looks like, and the socio-economic backgrounds from which criminality arises, could also impact upon an artist's treatment of their subject. In addition to this, institutions and other professional bodies are capable of exerting influence over when and how empathy is expressed. Arlie Hochschild

describes this latter problem in her book *The Managed Heart: Commercialization of Human Feeling* (1979):

> When rules about how to feel and how to express feelings are set by management…and when private capacities for empathy and warmth are put to corporate uses, what happens to the way a person relates to her feelings or to her face?[7]

As Horschild suggests, when emotional discipline is exercised within the workplace it produces a particular dialectic of empathy, one in which only some people are extended the right to express their feelings. One person's idea of professionalism is another's emotional purgatory. In the case of the courtroom sketch artist, I wanted to know when and how empathy is invoked or suppressed. Do the artists extend themselves emotionally, and for whom, and why? Does their profession even allow for it? Where does their loyalty lie?

In a bid to answer these questions, I spent time at the Old Bailey in London, the Central Criminal Court of England and Wales during the autumn months of 2017, in the hope of watching courtroom sketch artists in action. I wanted to experience the atmosphere in which they work, to imagine what it might be like to draw a trial, and to better understand their role in the legal ecosystem. After sitting in on a number of cases, what struck me was the way in which courtroom artists become witnesses themselves: to the court proceedings, the fate of the accused and accusers, and the general atmosphere of the trial. Most of the cases I attended related to asylum seekers from Afghanistan or Syria fighting for refugee status in the UK. (Generally, trials the public can observe are of this nature; the Old Bailey primarily holds civic and minor criminal cases.) During the first, I watched a young Syrian woman swiftly denied asylum by the judge – over the coming months, this became a disturbingly recurrent scene. Two weeks later, I watched the case of a middle-aged

white man who had racked up a large fine for unpaid parking tickets. There weren't courtroom artists in these trials, just a few public witnesses, members of the defence, and people from the prosecution.

After observing a number of trials I started to get the picture: courtroom artists draw celebrities and high-profile cases because they are sensationalised, emotionally evocative, and profitable. But I got a sense of the kind of environment an artist might be expected to translate: the dimly lit courtroom, the legal hierarchies, the orderly manner of the interactions and responses. The Old Bailey felt like Shakespearean theatre – incredibly grand, formal, and traditional. Tradition extends to how the judges are named: they are still all addressed 'Sir' or 'Madam'.

I watched six cases that autumn. During the last trial I made the following note in my journal: 'this form of witnessing makes artists also accountable in their "service" to the media and the legal system, while simultaneously bearing the weighty job of influencing public perceptions of the individual on trial'. In the days after, it seemed imperative I talk to someone who had negotiated this complicated and highly charged terrain. My enquiries led me to Priscilla Coleman, the woman who had drawn Amy Winehouse displaying her leg at her trial in 2009.

*

'Artist makes history by becoming first person allowed to draw sketches inside court,' declared an article on *Mirror Online* in October 2013. The court in question was the UK's Supreme Court, and, as the article explained, this was the first time a sketch artist had been permitted to record proceedings 'in almost 90 years'.[8] The Supreme Court is the only judiciary in England and Wales which permits filming. Because of this, an artist was also allowed to draw the proceedings – an appeal case concerning a

Christian couple who had disallowed a gay couple from staying in their guesthouse. That artist was Priscilla Coleman. I Googled her, and discovered that her sketches are regularly published on platforms including the BBC and the *Daily Mail*.

Having worked for 14 years as a courtroom artist in Texas, and for the last 12 in the UK, Coleman is a woman with a special insight into the ethical dilemmas particular to her profession, as well as the relationship between US and UK law.[9] Coleman moved to the UK 20 years ago on the lookout for work, owing to the steady decline in work for sketch artists in the US since 1987 when courts began allowing access to photographers. Previously she had worked for 7 years at an ABC station in Houston, Texas. Before I made contact with Coleman, I decided to research the equivalent legal restrictions in place in the UK, where the prohibition of photographs and sketches during the courtroom was first implemented in UK law in 1925.[10] Legal documentation produced at the time describes precisely what forms of representation were banned:

> 'photograph', 'portrait' or 'sketch' shall be deemed to be a photograph, portrait or sketch taken or made in court if it is taken or made in the courtroom or in the building or in the precincts of the building in which the court is held, or if it is a photograph, portrait or sketch taken or made of the person while he is entering or leaving the courtroom or any such building or precincts as aforesaid.[11]

The year 1925 may seem a long way from the present day, yet the legislature demonstrates a didactic approach to the representation of court proceedings which remains in place in the UK. There are a few special circumstances in which artists have been permitted to sketch in UK courts – such as the permission granted to Coleman – but they are scarce. Sketch artists are still largely forced to draw from recall after the hearing, taking written notes

and reminders while inside the courtroom to refer to at a later date. In this context, the job of reporting becomes entangled with a notoriously unreliable faculty: memory. (Surely, there must be many instances in which a subject is accidentally given glasses or an over-sized nose.) The sketch artist must also conform to the demands of media outlets, who may, for example, have a particular colour palette in use on set that artworks are obliged to complement.[12]

When eventually I met with Coleman on a November day at the Whitechapel Gallery in London, the role memory plays in her work was one of the first things I asked her to describe. 'I have to take notes,' she told me, 'so it sticks in my mind, as if you're studying for a test or something. It's a weird thing to do, but it makes people not so aware of my presence in the courtroom.'[13] Originally from Texas, Coleman's demeanour was reminiscent of other people I'd met from the state: sharply presented, professional, measured, and well mannered, yet also cautious.

There is a kind of exposure particular to the interviewee of which she seemed aware – the possibility that a subject's answers can be reworded to suggest an alternative dialogue, opinion, or persona – and she wanted reassurances about my agenda. Janet Malcolm's 1990 book *The Journalist and the Murderer* considers the ethical undertaking of journalism, famously describing the profession as 'morally indefensible'. Malcolm raises the idea that the journalist has the power to reveal something their subject doesn't necessarily want to be shown, to tell a story other than the one they want to be told. I realised that the ethical conundrum of portraying another person was as relevant to me, as an interviewer, as it was to her, as a sketch artist: both are practices of necessarily subjective witnessing. Yet unlike the interviewer, the sketch artist reports on their subject from a distance. Coleman's subjects are given no voice, no say in how they are portrayed.

When Coleman works she is under no obligation to draw the subjects in a certain light: the only requirement is to deliver the images promptly. In such conditions the failure of memory is a relatable shortcoming. If a courtroom artist forgets or misremembers, their mistakes can be understood as human imperfections – the result of a difficult job rather than a calculated strategy of misrepresentation. Yet Coleman has the power to construct a public narrative for an individual, a narrative that can be manipulated or enhanced by her use of light, or the exaggeration of certain gestures and features.

*

In recent years, sympathy and empathy have been widely theorised in academia, activist circles, and the art world. Phrases like 'radical empathy', 'collective care', and 'the politics of care' may have become buzzwords, but they are often used in emotionally charged scenarios, too – mental health situations, interpersonal dilemmas, and, of course, the criminal justice system. Political scientist Naomi Murakawa coins the term 'weaponised empathy' in relation to racialised police tactics, as a means of showing when empathy is abused by legal authorities. The weaponisation of empathy in this domain, she writes, operates as 'a tool to dull resistance to the routine racial terror of policing – racialised suspicion and the processing of mass citations and arrests'.[14] Weaponised empathy often manifests as the police constituting an appearance of being caring and advertising 'liberal' credentials, in order to detract attention from structural violence. As such, empathy is instrumentalised to give a false facade of protection, governance, and safety.

The role of the courtroom sketch artist led me to consider the difference between sympathy and empathy, a train of thought that brought me to Leslie Jamison's essay collection *Empathy Exams* (2014). Jamison writes that 'empathy isn't just something

that happens to us – a meteor shower of synapses firing across the brain – it's also a choice we make: to pay attention, to extend ourselves'.[15] This sentence stuck in my mind. Jamison proposes that individuals have control over empathy, the degree to which it is experienced, and for whom and what we feel it. Did Coleman view her art as an opportunity for this kind of conscious extension – a way to reach out to others, to acknowledge them? 'I probably have general sympathy with everyone's face,' she told me:

> because there is a way people can look better than they would normally – for example if a barrister or judge is looking down they create this double chin which they probably won't have if they're looking up. I don't want to show that if I can avoid it. They don't have to look bad. They can look their best self.[16]

While empathy suggests an ability to understand and share the feelings of another, in contrast, sympathy is the act of comprehending misfortune. Empathy can be both an active function and a cognitive choice. As the writer Roman Krznaric puts it, it is 'the art of stepping imaginatively into the shoes of another person, understanding their feelings and perspectives and using that understanding to guide your actions'.[17] With this in mind, I wondered what it meant for Coleman to describe having 'general sympathy' with someone's face, and whether it extended beyond the desire to look good. In her illustrations, can we identify empathy through the portrayal of emotion?

It is through our encounters with other people's faces that we learn to interpret emotion. In some courtroom sketches the background is blurry, or the walls filled in as a colour block – in these instances, the details of the architecture have been deemed surplus to requirements. (The drawings of the cult leader and serial murderer Charles Manson from his 1968-71 trial are a case in point. In these sketches he takes centre stage, like some kind of

rugged monster, the background completely blacked out – further reinforcing his morose, hippy-turned-psychopath demeanour.) This aesthetic code emphasises that people are always the focus. 'To respond to the face, to understand its meaning, means to be awake to what is precarious in another life, rather, than the precariousness of life itself,'[18] Judith Butler writes: the face is the most exposed and vulnerable part of someone else, the locus of empathy, a site of encounter, receptivity, and entanglement. Yet what I found compelling about Coleman was her emotional disengagement from the subject at hand. Commentary on such serious subjects as power and representation at trial was frequently followed by laughter or distasteful jokes. The conditions under which labour is undertaken are often intertwined with emotional expectations placed upon the worker. Therapists, teachers, social workers (to name a few), and, of course, those in the medical industry all are bound to professional constraints which demand emotional control and regulation. These demands don't escape the courtroom artist, either. Had Coleman had to harden her emotions to carry out her job, I wondered? Yet on talking to her further, something akin to an empathetic awareness became apparent in her self-knowledge of the limitations of her emotional and artistic perspective – and the effect this may have on the individual on trial. She described to me how she 'doesn't like to have eye contact with these people too much,' because she 'doesn't want to unnerve them'.[19]

*

Trials are symptomatic of how the criminal justice system uses time as an emotional weapon. The UK Ministry of Justice reports that the average criminal case takes around 'twenty-four weeks in total'.[20] From the moment of arrest to the actual court hearing the accused citizen anticipates the trial, anticipates the possible sentence, anticipates the inevitable lack of control

and summoning to prison. This anticipation affects how people behave and feel in court. Temporal precariousness is reflected in Coleman's illustrations, as her court scenes document what happens before a decision is made about a person's future, moments before the verdict.

Coleman's art is subjected to intense environmental pressures – sometimes, she told me, the conditions are such that she may even find herself 'requiring binoculars to scrutinise the expressions of the subjects as they give sworn testimony'.[21] She described how simple things, such as the seat she is allocated by the court, may also have an impact upon what she produces – it 'affects what I can see and take notes of,' she says. 'It affects how the people in the room are drawn.'[22] When we met, she explained that the demand for her images is such that almost immediately after completion, 'a sketch is photographed against the nearest available wall'[23] by press agencies. Coleman mainly makes her drawings in 20 to 30 minutes after the trial – not long, to decide upon the public image of the accused.

*

Formal spaces of criminology, correction, and punishment create order: they structure, define, reproduce, and sanction. I arrived at questions of affect while considering the fraught subject of institutionalisation, and deliberating upon how courtroom artists might, and indeed do, feel and assert their emotions in an environment which may demand restraint on their part. The academic terrain known as 'affect theory' is more concerned with what emotions do, than what they are – how they influence action, ignite reactions, and constitute selfhood. To me, in a society where we are encouraged to enact individualism, this call to awareness feels like a plausible – and indeed crucial – step in the direction of a more conscious, interrelated way of being. Alongside Lauren Berlant and Sianne Ngai, feminist scholar Sara

Ahmed tentatively explores the political dimension of emotions. As she writes in *The Cultural Politics of Emotion* (2004), 'a claim about a subject or a collective is clearly dependent on relations of power, which endow "others" with meaning and value'.[24] If we are to take Ahmed's claim, that meaning and value are dependent upon relations of power, perhaps in bearing witness to the relationality of the courtroom, sketch artists can tell us a great deal about the affective place from which their drawings are created.

Working in an environment where emotion runs high is a concern for Coleman: 'I worry about making them look guilty,' she told me.[25] Experiences of guilt are bound to feelings of responsibility, and the complexity of Coleman's guilt can be read through Horschild's examination of this emotional state and the tensions it produces. Horschild writes, if 'guilt upholds feeling rules from the inside: it is an internal acknowledgement of an unpaid psychological debt. Even "I should feel guilty" is a nod in the direction of guilt, a weaker confirmation of what is owed.'[26] To be guilty, and to have an awareness of guilt, are part of the nature of Coleman's job: it seems perfectly right that she questions this emotion.

*

Trials do not consist of a single person in a courtroom. The accused may also be accompanied by barristers, jurors, prosecutors, and members of the public watching from the viewing gallery. As such, most of the courtroom sketches I've encountered depict more than one person. In the absence of a camera, the artist's purpose is to capture the moment and the mood, to produce a freeze frame of the central cast. The faces in Coleman's sketches linger as carefully orchestrated images, which weave a narrative of legal relationality. A drawing of Heather Mills pouring water over the head of Paul McCartney's lawyer during their divorce

trial in 2008, from which she was awarded £24,000,000, is among the most emotionally charged of her illustrations. The lawyer is portrayed as frail and unassuming, while Mills's stance is confident and aggressive.

When it comes to choosing what cases to cover, Coleman says she tends to go for the 'newsworthy ones, because money-wise, that's of interest to the newspaper'.[27] In this way, crime becomes a commodity: a quandary that keeps images of the accused in the news, and the court artists in their seats, a process of capitalising upon the legal system. Surely, then, as viewers it is our responsibility to question why we might accept these portraits as a source of truth in the first place, or at the very least accept the flaws and complications this unusual mode of 'legal art' presents.

C. Douglas McMillon 'CEO of Walmart' (2015): ballpoint pen and pencil on paper. Captured by Charles Lytle (Prison ID #16684648) Courtesy of The Captured Project.

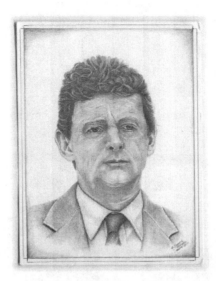

Tony Hayward 'Former CEO of BP Oil' (2015): black bic pen on 100lb vellum paper. Captured by Benjamin Gonzalez Sr (PRISON ID #17554404) Courtesy of The Captured Project.

Garrett Rushing 'CEO of Citigroup' (2015): oil on canvas. Captured by Garrett Rushing. (PRISON ID #10706-091) Courtesy of The Captured Project.

Where Accountability Lies

For within living structures defined by profit, by linear power, by institutional dehumanization, our feelings were not meant to survive.
Audre Lorde

'Don't touch me please' and 'I can't breathe' were the cries of Eric Garner, an African-American man who was choked to death in a headlock by NYPD officer Daniel Pantaleo, on a side pavement in Staten Island, New York City on 17 July 2014. As shown in the video widely circulated on social media outlets following the incident, his pleas were ignored by the group of predominantly white police officers surrounding him. Despite his death being ruled homicide by the coroner, Pantaleo was never prosecuted. For many, the murder symbolised the racist and longstanding failures of the US criminal justice system, igniting Black Lives Matter Protests across the country. Garner's death made clear a deeply entrenched racial disparity: if you're black, not only are you unprotected by the state, your death isn't considered worthy of legal accountability; if you're white, not only are you protected, you can also subvert the law in your favour.

Since my research for this book began in 2016, I have been continually distressed by witnessing how large corporations and law enforcement get away with crimes – in part due to their access to finance, but also because they aren't already stigmatised like those lower down the socio-economic ladder. Inconsistencies in who gets prosecuted and for what crimes demonstrate the flaws of a criminal justice system that systematically enables mass incarceration, while failing to hold certain individuals accountable. Often, large corporations escape criminalisation by agreeing to pay a settlement fee, while people of colour, women, and individuals from poorer backgrounds face lengthy sentences

for minimal crimes. While bank executives who launder drug money walk free, opioid addicts are jailed for selling a few pills, echoing the corrosive 'three strikes' and 'mandatory minimums' enforced under the California Penal Code Section during Bill Clinton's presidency in the 1990s. In such a climate, it becomes acutely apparent that in the eyes of the state some lives are predestined for punishment and others for freedom. In this chapter, I enquire how artists, activists, and inmates respond to the discrepancies in incarceration rates, and how they go about challenging those who are not held legally accountable for their crimes because of their financial status or the colour of their skin.

In 2016 Jeff Greenspan and Andrew Tider, two US-based activists/artists, launched the project Captured: People in prison drawing people who should be. Captured sought to confront the racial bias within the penal system, by comparing portraits of those held accountable for their crimes with those who aren't. The portraits raise pressing questions. Who gets locked up, and why? How is the function of justice abused? On the Captured website, Greenspan and Tider explain the process and the concept behind the project. The pair say that they 'asked people in prison to paint or draw people we felt should be in prison – the CEOs of companies destroying our environment, economy, and society'.[1] In an effort to uncover the multiple lives touched upon by Greenspan and Tider's satirical portraits, and unfold the nuances, I began writing down questions. Could Captured be an example of 'ethical portraiture' which functions as a form of activism, generating accountability in the face of systemic injustices? Does placing CEOs – drawn by prisoners – adjacent to their crimes genuinely create political recognition for the failure of justice? In its attempts to make explicit perpetual injustice, does Captured also repeat pre-existing problems of media representation and social norms, by dictating who and what is given visual space?

In 2016 Tider and Greenspan published Captured as a book, with a layout that makes explicit the socio-economic segregation between those on the inside and those on the outside. Upon opening the publication, the reader encounters double-page spreads presenting the free and the incarcerated. On the left are illustrated portraits of CEOs – mostly white, cis men – such as Jamie Dimon from JP Morgan, and Stuart Gulliver, group executive of HSBC, along with details of their crimes. On the right information regarding the inmates who drew their portraits is printed, including their names, prison numbers, and descriptions of their crimes. There are no illustrations of those behind bars. A portrait of C. Douglas McMillon, CEO of Walmart, is captured in ballpoint pen by Charles Lytle, who is serving 9 years for robbery and assault. Besides McMillon's portrait is a list of the crimes for which he has never served time: bribery, looting the public, public endangerment, stealing workers' wages, and, of course, tax evasion. Also included in the book is a portrait of BP's former CEO Tony Hayward, notable for overseeing the Deepwater Horizon Oil Rig – cause of the largest marine oil spill in the history of the petroleum industry in the Gulf of Mexico in 2010. The spillage resulted in the death of 11 workers and further injuries. Yet while BP was charged with federal criminal charges, and pled guilty to 11 counts of manslaughter, two misdemeanors, and a felony count of lying to Congress, Hayward was able to simply resign and today walks free. Hayward's portrait has been skilfully drawn by inmate Benjamin Gonzalez Sr, who is serving 9 years for robbery.[2]

By asking prisoners to draw those who they feel should be in their place, Captured exposes the perpetual failure of justice to hold to account the CEOs of companies who are destroying our environment, economy, and politics. The project is also testament to an unremittingly broken society in which many individuals become perpetually bound to the criminal justice system, often through debt, unpaid fines, habeas corpus extended through

pressure for plea bargains, small drug charges, and other minor offences. In the 2016 Netflix series 13th, Michelle Alexander – author of the groundbreaking book The New Jim Crow (2010) – describes the prison-industrial complex as 'a machine which consumes bodies'. Expressing a similarly grim sentiment, a friend recently compared the prison system to an abattoir.

The entrenched racism of the prison-industrial complex, and the issue of prison privatisation, was a focal point for Bernie Sanders during his 2016 electoral campaign. Not only did he push for the abolition of private prisons, he also made a strong – and indeed plausible – prediction, backed by the Bureau of Justice, that one in three black males can soon expect to go to prison during their lifetime if current incarceration rates remain unchanged. Responding to the mass incarceration of African-Americans and Hispanics, the National Association for the Advancement of Colored People (NAACP) released a Criminal Justice fact sheet in 2019, reporting upon the specific disparities within the penal system. It notes that one in every 37 adults are under some kind of correctional supervision in the US – and that currently, African-Americans are five times more likely to be imprisoned than white men. By extension, it is hard to imagine any application of 'justice' which doesn't lobby against the dismantling of mass incarceration, making Sanders' – and, perhaps, Captured's – ethical undertakings all the more urgent to consider.

*

In part, I chose to interview Greenspan and Tider because I was interested in their agenda and political position. After exchanging a few emails we arranged to chat over Skype, as they were based on the East Coast while I was in the South West. When we connected one Tuesday afternoon in February 2017, Greenspan explained: 'It's an activist project in the form of an art

project.'[3] He described how they set about building a network of prisoners to draw the portraits – and the complications their overtly political project faced:

[We] reached out to people who worked doing art therapy in prisons, but these individuals did not want to be seen doing anything that seemed political or anti-corporate. Somebody in one prison in one state would write a letter to a friend in another prison in another state saying 'Hey, you gotta meet Andrew and Jeff, they're doing this project, write to them here and they can tell you if you can be involved.'[4]

This network of prisoners was initially constructed, Greenspan said, 'online, mostly through eBay and Facebook,' where they 'found people that were selling or showcasing prison art portraits in the form of paintings and drawings. We then reached out to those people who posted them, who usually were the brother or son or father or relative of one of the incarcerated artists.'[5] Greenspan and Tider controlled which subjects the prisoners portrayed, providing images sourced from the internet and media:

that would be like press portraits for the CEOs and presidents of the corporations. We asked them not to editorialise because the project in itself is editorialising and has a specific message. So we got a few where the CEO was perfectly drawn and looked exactly like the photo or photos we sent, but the tie of the CEO had dollar signs all over it or the CEO had devil horns or a forked tongue.

They took the decision to provide the images themselves because of the environmental constraints of prison, which meant inmates weren't able to source their own images (or indeed draw from life). Regardless, the decision raises interesting questions as

to whether and to what extent prisoners were free to express themselves.

The majority of drawings of 'free' subjects in Captured are based upon boardroom-style portraits. Upon opening the book, the viewer is confronted with a series of figures, each posing in a hyper-masculine and authoritative stance. Generally, they have been drawn with meticulous attention to detail, and encompass caricature and realism: the viewer can distinctly see each artist's own take on the subject before them. Lytle's drawing of Mcmillon, CEO of Walmart, is particularly unnerving. Like a person posing for a high school yearbook photograph, he peers gleefully at the viewer, his body depicted against a nondescript terrain. The pose is uncanny for the manner in which it resembles other portraits included in the book, such as that of Michael Corbat, CEO of Citigroup, whose crimes are listed as conspiracy, economic deconstruction, fraud, and illegal credit card practices. Corbat was drawn by inmate Garrett Rushing, who is currently serving 17 years for drug trafficking with a firearm and possession with intent to distribute.

Corbat was investigated in 2014 after Citigroup's Mexican division, Banamex (the largest bank in Mexico), was accused of extensive criminal activity. As the Citigroup website states, 'the investigation uncovered illegal conduct, including fraud in the range of US $15 million, the unauthorized application of security services to outside parties, and the use of intercepted telecommunications'.[6] The question of accountability was turned back on him by the press – and his prior track record was hardly clean. Under his watch, Citibank misled many people into subprime debts and mortgages, and charged people during 'trial free periods'. Following the 2008 fallout, Citigroup was among the eight largest US banks to receive capital investment from a Treasury Department fund established to 'help banks in tough times'[7] – courtesy of taxpayer cash.

It doesn't take a genius to unravel the application of 'criminality' here, and the way in which the crimes of which Corbat is accused impact upon some of the most vulnerable in society. His alleged actions add to the corrosive cycle of debt – one which, as the financial crisis of 2008 exposed and the conditions which preceded it have proved, hits people of colour the hardest. As Jackie Wang puts it in her book, Carceral Capitalism (2018):

> Almost daily, new scandals emerge across all domains of borrowing. This points to an accumulation crisis that companies and lending institutions are trying to stave off through fraud, manipulation of interest rates, the automatic charging of fees, debt collection harassment, and naked expropriation.[8]

The perpetual incarceration of African-Americans and Hispanics is also due to the vicious cycle of debt, which puts vulnerable people in a position where they turn to criminal activity to survive, often accumulating fines, unpaid warrants, and court charges. This cycle can be traced to subprime mortgage loans issued prior to 2008, and the corrupt activities of banks like Citigroup, Bank of America, and Wells Fargo – all of whom appear in the Captured project. In Tider and Greenspan's book, the debt trap is also represented by the portrait of CEO Jamie Dimon of JP Morgan, who is accused of similar crimes to Corbat, alongside price fixing and securities fraud, and CEO of Wells Fargo John G. Stumpf, who is accused of conspiracy and theft. Dimon is perhaps most famous for his bitcoin laundering, which was widely criticised in the press. In a 2017 Medium article titled How is a corrupt criminal like Jamie Dimon, not in prison for fraud?, journalist Blair Erickson remarks, 'while the people are building new financial systems that offer real transparency, accountability, and value, corrupt banksters like Jamie Dimon have spent their time trying to figure out how to stop them or warp them to their own hierarchy's benefit'.[9] This being the case,

the comparison to the artist who drew Dimon, Jose Fregoso, who is serving 9 years for robbery, seems like a particularly unfair application of justice.

Fregoso has drawn Dimon in pencil, giving him a quietly confident expression and a gloating smile. The shading fades out as it reaches Dimon's torso, as though his head resides in a spotlight. Like many of the portraits gathered together for Captured, there is a humorous tone to this depiction that amplifies the smugness of the pose. Utilising satire to expose what goes unquestioned is central to the project. There is a strong history of activists using dissent, parody and humour as a tool to deconstruct and expose the absurdities of institutional power and corruption. The UK anti-Brexit guerilla group Led By Donkeys, which began operating in 2016, used the analogy of a donkey to describe those in political power guiding the so-called Brexit deal. The term 'lions led by donkeys' finds its origins in World War One, where competent lions (the soldiers) were led carelessly to their death by their irresponsible leaders (the donkeys). I'm sure we can all think of political situations where this might be the case. In a similar spirit, frivolous political parties – such as The Rent is Too Damn High Party in the US, and the Death Dungeons and Taxes Party in the UK – perform satire while also seeking to influence real policy. Satire's ability to unveil political truths was a methodology undertaken in the production of Captured, too. As Greenspan put it: 'there's something humorous about re-appropriating those people with this package. Of course they'd have a very different face if they knew they were being told they were going to be in a line-up of the most wanted CEOs.'[10]

*

In addition to humour, I was keen to know about the historical and stylistic references of the portraits produced as part of Captured,

which differ from typical images of prisoners. Were they made in relation to a traditional model of portraiture, one that aims to capture someone's character, expression, or something personal to them? Greenspan explained that they 'were going in line with what the modern version of the old lord or king portrait would have been, so the modern version of that, sort of the boardroom photo – down looking, behind a desk wearing a suit or a blouse'.[11] Boardroom portraits are a statement of authority. In corporate settings they assert capability, worth, and status, and are often situated in formal work environments. The boardroom itself also operates as a private space within a company – separate from employees in lower positions – where major decisions are made. The portraits which adorn these spaces are intertwined with a history of privilege and are often presented in gilt frames, thus extending the illusion of 'importance' and affirming who is allowed in the room. As such, boardrooms are spaces that intersect prehistoric and contemporary power, in which portraits of their inhabitants function as an aesthetic reminder of governance, status, and, above all, institutional and social hierarchy.

Traditional boardroom photographs are similar in style and function to governmental portraits. In the US, governmental portraits are usually conducted following the election of a president or new employee of the White House, and paid for by the tax-payer. Portraits of Barack Obama, Donald Trump, and Ronald Reagan were all produced under the same oil painting scheme, reinforcing the sentiment that not only are these people worthy of representation, but that it's also the public's duty to cough up for the process. Much like those found in Captured, these portraits all share an aesthetic sensibility – authoritative stances and figures dressed in suits. In 2018, Trump ended the programme under the Eliminate Government-Funded Oil Painting Act, known as the EGO Act. Strange for a man who epitomises narcissism, although perhaps he wanted his

presidential painting to be the last – the ultimate documentation of a grotesque white man ruining the United States. Trump aside, the EGO Act does put a stop to an expensive precedent: the portraits cost around $40,000 a pop – the average income for many US households.

*

Within the Captured project the inmate is only rendered visible through the portraits of those who are free. Added to the fact that prisoners were also provided with subjects to portray – and specifically asked by Greenspan and Tider not to 'editorialise' – the project raises questions. Through trying to expose the disparity of injustice, does Captured offer the participating artists an opportunity for revenge, as opposed to reconciliation or personal expression? Does the project tackle unequal treatment and representation, or does it weaponise an ethical quandary? And, in asking inmates to portray wealthy, free CEOs in order to illustrate the plight of their own incarceration, do Greenspan and Tider risk reinstating an injustice which already persists, or do they formulate the possibility for representational transformation? In her brilliant essay Recognition Without Ethics (2000), Nancy Fraser proposes that 'recognition [is] a question of social status'.[12] Recognition, for Fraser, is intertwined with pre-existing institutional patterns of cultural value which we are all implicated in and by. When these patterns are enforced they influence how we are represented, protected, and perceived. Despite their project's political intent, Greenspan and Tider's decision to only make the CEOs visible risks reproducing the same patterns of power and recognition that helped secure the legal freedom of the wealthy in the first place. In 2017, Netflix released Strong Island, a 2017 true crime documentary that told the story of an African-American named William Ford, who was murdered in 1992 by a white 19-year-

old shop owner in Lake Grove, New York. Made by William's brother Yance, *Strong Island* interrogates the associated trauma Yance and his family suffered. Unlike *Captured*, Yance made the decision not to give space to the story of the white criminal – and in the process, avoids repeating the patterns of power and recognition that protect and reify the status of white men. 'I have never, not once tried to imagine what he looks like,' Yance says. 'I think he looks like, no offence to present company, every white man I've ever seen. I think he looks like the ticket taker, the guy in front of me buying a beer at the bar, I think he looks like the shmuck who took my cap, he looks like my physical therapist. He looks like anybody, anyone, everyone, he's everywhere.'

Rather than offering prisoners the chance to tell their stories, *Captured* generates indirect recourse to visibility through depicting the criminality of others. Tider considered the project to be 'overall empowering for people that don't have any power'.[13] Greenspan explained that 'money, power, and political influence allow these companies, and their leaders, to not just break the rules, but make the rules,'[14] but where were the prisoners' voices in this project? I asked Tider whether prisoners felt they were humanised by the project. 'Some people definitely felt that it gave them agency but I think that the agency, in most cases, was less about these CEOs being terrible, and more feeling glad to be able to speak up. It made them feel more human', he replied.

> People say...this is the first time that I've gotten to do something positive in the last 2 years, or this is the first time I've ever used my artistic talents, or this is the first time I've ever made honest money doing anything. So those [comments] were very heartwarming and seemed to imply that people felt some kind of control over their lives, if just for this brief moment.[15]

The project also had personal repercussions. 'I'm glad that I'm getting to speak up,' Tider told me. 'It's making *me* more human that I'm doing this.'[16]

In a certain light, Greenspan and Tider do manage to give agency back to inmates, while also offering public recognition of how they have been unfairly treated by the criminal justice system. But I believe that this could be extended further – and that the involvement of prisoners could have moved beyond the production of portraits of more privileged subjects, perhaps by asking them to create self-portraits of their own. *Captured* is certainly a gesture in the right direction – a yearning of both instinct and responsibility on behalf of the artists involved. How much the project reflects and recounts the lived positions of the artists involved, I remain unsure.

Lynette Newson, Correctional Institute for Women, Corona, California.

Anonymous Backdrop painted in Pennsylvania State Correctional
Institution, Houtzdale. As the artist was sent many of the images
by prisoners, they were not accompanied by dates, materials, and
dimensions. Courtesy of Alyse Emdur, Prison Landscapes.

Backdrop painted by Darrell Van Mastrigt in Pennsylvania State
Correctional Institution, Graterford.

Prison Landscapes

*Until we can understand the assumptions in which we are drenched
we cannot know ourselves.*
Adrienne Rich

While travelling around the Mid and South West of the US
between 2017 and 2018, I intermittently experienced feelings
of melancholy and alienation. These feelings were spurred on
by the vast barren landscapes and gothic farms dotted along
Tornado Alley, and the great plains which constitute the south-
central bible belt; the harsh desert terrains of Oklahoma, and
the piercingly brutal landscapes of Minnesota, adjacent to the
industrial-style buildings of Minneapolis. Further South West, in
the Texas pan handle, I found the deserts particularly desolate.
The rule of law feels acutely precarious, something that could
be revised at will. Here, the American dream that 'you can
be anybody you want' functions as a disguise for policies of
violence, and complex socioeconomic and political injustices.
That's what a guy in a gas station in Omaha told me, anyway.

A similar feeling of melancholy washes over me when
viewing Prison Landscapes, a project by the artist Alyse Emdur.
My interactions with Emdur took me on a journey towards
understanding the role that imagination, and the landscape,
play for those incarcerated in the US. The project, which started
in 2005 and culminated in a book in 2013, brings together one
hundred photographs of inmates standing in front of painted
backdrops in prison visiting rooms. All of the portraits, which I
find both profoundly moving and eerily sombre, were taken by
inmates in prison visitation rooms.

Along with the portraits, Emdur also took photographs of
the depopulated wall paintings in visiting rooms. These empty
landscapes are mesmerising and tinged with sadness. Often

luminous in colour and optimistic in composition, they are visions of other worlds, documentation of imagined existences of non-confinement. Natural landscapes are frequently referenced: waterfalls, tropical beaches, and sunsets give form to a wish for freedom, for exemption from incarceration. Golden orange sands are juxtaposed with aqua blue seas, each painting distinct in style, and produced in a visual language very different from the grey prison walls. There are forests in which bears peer longingly into the distance, and landscapes with Christmas trees. Other murals depict iconic city scenes and recognisable cultural monuments, such as the Statue of Liberty and the Grand Canyon. These landscapes beckon a state of dreaming, where fantasy permits the inmate a reprieve from the reality of incarceration. They create a space for something, and somewhere, *other*.

In the introduction to her book, Emdur writes: '*Prison Landscapes* explores this little known and largely physically inaccessible genre of painting and portraiture seen only by inmates, visitors, and prison employees.'[1] The paintings share an affinity with the history of the mural, which functions as a mode of integrating alternative realities into everyday environments. Often placed in underpasses, large buildings, and subways, and on the ceilings and walls of hospitals, schools, and prison visitation rooms, they are capable of counteracting and infiltrating the visual politics of public space. In *Historical Geographies of Prisons: Unlocking the Usable Carceral Past* (2015), Susana Draper claims that murals in prison are 'a simple, but potent, form of telling,' which demonstrate 'collective reflection on the relation between architecture and bodies, posing the sense of freedom (a form of walking together) intimately tied to a material practice'.[2] For Draper, storytelling is a mode of imagining the imprisoned person as something *other* than a prisoner, by deflecting the visual context in which they exist.

One of the most striking examples of the history of prison mural painting began nearly 60 years ago on the south coast of

Florida. In the 1960s, office buildings and motels were the only businesses which would purchase artwork from black artists in the latter half of the twentieth century. One man in particular, Al Black – an African-American artist, born in 1940 on a plantation in Mississippi – worked as a salesman for other artists, and later became affiliated with the artist group The Highwaymen. Legend has it he sold paintings out of the trunk of his car to tourists. He also painted landscapes himself. When Black was incarcerated for a decade in the Central Florida Reception Center in the 1990s, a prison and medical facility in Orlando, he painted vivid murals on the prison walls. The colour in his work – luminous pinks, greens, and blues – is more stark than that used in the murals photographed by Emdur, making the desire for an alternative physical reality particularly acute. The subject of his landscapes is Florida's south coast. His art is a picture-postcard vision of the Sunshine State: palm trees, blue seas, and melancholy swamps captured from afar. Today, even the local government recognises the cultural currency of The Highwaymen's work; several of their murals are on display at Miami International Airport.

A few left-leaning states in the US have shown awareness of the value of artistic forms of expression as a mode of rehabilitation. (I am sceptical about the rhetoric of 'rehabilitation', owing to the fact that larger socio-economic and political factors play a substantial role in how a convict may integrate back into society, but it is reassuring to see that funding is at least being allocated to creative pursuits.) Arts in Corrections, California, a funded initiative partnership between the California Arts Council and the California Department of Corrections and Rehabilitation (CDCR), runs mural painting classes as part of its programme. The programme has been used by the prison system since 2013, and seems to be receiving positive results. In a Justice Policy Report from autumn 2014, Professor Larry Brewster conducted extensive research at the Center on Juvenile and Criminal Justice about

the CDCR programme, in order to document the behavioural and psychological impact of art workshops. In Brewster's investigation, two male inmate populations participated in the strictly voluntary programme, and after undertaking art classes for up to 5 years, 46 per cent 'liked themselves better', 33 per cent had cleaner disciplinary records, and 41.5 per cent said they signed up because 'they wanted to change their life'.[3] All the more reason, then, to fund such programmes, particularly if they foster a sense of self worth among the incarcerated. Similarly, the organisation Project Paint, launched in 2013 at Richard J. Donovan Correctional Facility in San Diego, focuses exclusively on the medium of painting, and also includes mural painting sessions. Inmates often don't get to paint directly onto visitation room walls, like the artists who produced the murals Emdur photographed, and instead work on canvas. Yet the aesthetic and subject matter is remarkably similar: beaches depicted in electric oranges and striking blues; valleys with meandering rivers trailing off into hazy peach sunsets; mountains and snow.

In early 2016 I spoke to Emdur over Skype – I was in London, and she was based in Los Angeles. It was an eye-opening conversation, one which left me inspired, hopeful, and thoroughly informed. Emdur told me that her older brother has spent time in prison. *Prison Landscapes* originated from her own involvement with the penal system, and her political beliefs concerning the psychological impact the criminal justice system has upon those it incarcerates. 'I am in part the collateral damage of the prison system,' she said, 'in the sense that I lost my brother for over a decade to the war on drugs.'[4] A polaroid of Emdur with her brother, included in the book, reveals the genesis of the project. 'It all started from this family photograph that I found of me and my brother, posing in front of an idealised backdrop in a state prison in New Jersey when I was 5 years old,' she told me. 'The project is rooted in an emotional and empathetic place.'[5] Emdur was keen to make visible the isolation

experienced by those on the inside, and prisoners' longing for human contact. 'Loneliness is the desire to have a connection with someone from the outside,' she said, and it is this that 'fuelled many participants' motivation to be part of the project'.[6] In the painted landscapes Emdur photographed, inside and outside are collapsed, rendering an instance in which difference can be imagined. Of all the prison portraits and artistic projects I've encountered, Emdur's pose the possibility of a feasible momentary escape for prisoners, albeit one that is bittersweet – a moment in which they are able to reimagine their physical existence, within the penological structure, producing a new form of portraiture from the inside.

In these murals reality flickers, contours, and changes; the aesthetic of the prison rubs against that of the painted image, producing a kind of semiotic tension. Due to their physical confinement inmates are often powerless over how they interact with, or are represented to, wider society. In part, what led me to Emdur was her understanding that visual imagery can be humanising and function as a mode of agency. Emdur began commissioning and compiling the images in *Prison Landscapes* by writing to inmates. She explained that to make the project work, she had 'to be vulnerable in the letters' and share with her correspondents 'honest personal information'. This, she told me, 'is what I got back in return – a level of respect'.[7] During the course of our interview, it became apparent that despite being emotionally interlinked with the system herself, she intended the project to include no trace of the prisoners' criminal history. She explained that she didn't want her presence to have an impact, and that she 'wanted people to represent themselves'.[8] I consider this to be a mode of political responsibility, a way of allowing prisoners to be represented without reducing them to the crimes for which they have been convicted. 'The images can make people feel uncomfortable, because you're faced with someone's humanity and you know they're convicted for a crime

but you don't know what that crime is,' Emdur told me.[9] Being photographed in a landscape other than the one in which they are legally held enables prisoners to assert their individuality as a gesture towards freedom, to manifest an alternative to official documentation, and to reject the prevalent typecasting of 'criminals'.[10] 'Most people who I've written to are very fond of the backdrops, they see them as a way to represent themselves more humanely,' Emdur said, explaining the appeal of the murals to prisoners. 'It is more pleasant to see these paintings than to see barbed wire or a brick wall.'[11] The stillness of the images beckon towards a dreaming for inmates, where their reality is momentarily punctured – forgotten and resolved.

While undertaking my research I came across another project which shared an affinity with *Prison Landscapes*: the *Supplication* (2011-2013) series by American photographer Kristen Wilkins. Focusing specifically on incarcerated women, Wilkins explains that she 'worked with women to document places they missed, paired with their portraits'.[12] Wilkins does not attempt to remove her subjects from their physical reality – instead of posing in front of painted backdrops, they sit on the carpeted floors of prisons. By coupling her subjects with their favourite places outside the prison walls, her artworks signify that 'outside' is not a place lost to their pasts, presents, or futures, but a place vividly alive in their thoughts. *Supplication* is a subtle, autobiographical reminder that prisoners' identities extend beyond the prison. The portraits Wilkins produced focus equally upon memory, and emotional ties to places from which their subjects have been estranged, as much as they do the women's present physical reality.

Like *Supplication*, the *Prison Landscapes* portraits also avoid identifying their subjects solely as prisoners. The people posing before the murals do not wear orange jumpsuits, nor are their prison numbers displayed. The images, Emdur told me, are:

stripped of many visual clues, which allows the public to empathise with them more. If you look at the images on their own you would not know they are criminals. The book is also about showing the humanity of prisoners and I think I did that by not including the crimes that people have been convicted of, so there's no contextual information.[13]

The photographs do at times, however, reference inmates' former lives. Sometimes, Emdur explained, the backdrops are 'gritty urban neighbourhoods or cities where the prisoners lived before they were incarcerated'.[14] Photographed against these scenes, inmates exist in an ambivalent territory – residing somewhere between a penologically disciplined subject excluded from society, and a reimagined self at liberty. Crucially, these images are also a form of portraiture which seeks to connect with the imagination of its subject. As Jackie Wang has written: 'imagination is excess, is that which could never be contained by the prison, that which will always exceed it'.[15] Wang reminds us that imagination – a faculty that permits the mind to travel elsewhere – is not bound to architectural constraints, and has its own, immaterial reality.

As we discussed the ethics of care, abolishment futures, and the importance of imagination, Emdur explained that 'Prison Landscapes revealed the extent to which the system is hiding itself.' When I asked about her visits to some of the institutions, she told me that 'most prisons are very hard to find'.[16] The rhetoric of 'out of sight, out of mind' determines how the government positions prisons geographically. They, 'are often in remote areas, miles from towns and cities, difficult to visit and gain access to,' she continued. One in a hundred adults live behind bars in the United States, proving that the expression 'prison nation' isn't one made in jest. That prisoners by and large remain hidden from public view is symptomatic of a wider push to render 'problem people' invisible through institutionalisation.

(LGBTQIA+ people, the homeless, disabled people, criminals, and the mentally ill have all suffered this fate in the present and historically.) *Prison Landscapes,* Emdur told me, 'is really about showing the opacity of the prisons and the level of control that the system has over its own representation'.[17]

*

The media, and in particular the television and film industries, also play a substantial role in obscuring our understanding of where prisoners are located. Because of onscreen depictions, we tend to imagine US prison visiting rooms as places where two people face one another, sitting on either side of a pane of glass or perspex, communicating via a phone. This type of location is called a non-contacting (NCV) visiting room, and is usually only found in high security prisons.[18] The photographs in *Prison Landscapes,* however, are an example of contact visitation, which takes place in large, warehouse-like rooms with a number of chairs and tables, where inmates can talk to visitors for up to 90 minutes. These spaces, often found in low- and minimum-security prisons (of which there are a great many), are also where prisoners have their photographs taken, alone or with visitors. The prison visiting room photographs, sometimes referred to as 'click clicks',[19] are seen as a service by prison authorities and not representative of anything artistic.

I was surprised to discover that the 'click clicks' programme is a service provided by most prisons nationwide. In federal and state facilities, it functions as a subculture where prisoners take pictures of other inmates, which are then mailed to their loved ones. You can get hold of the photos very easily, too – I've read several instances on online forums such as Prison Talk of those on the outside mailing image requests to prisoners, and receiving the photographs fairly quickly. The backdrops – usually painted on canvas or cinder blocks – are visual gestures which intend

to present the inmates as everyday citizens. As such, the 'click clicks' programme puts agency back into the prisoners' hands through the instantaneous action of the camera. Yet Emdur told me that there is also a social hierarchy of who can have their photograph taken. In some instances, she said, 'you can only get your picture taken if you have a visitor'.[20] Without visitors, prisoners may have to pay to be photographed.[21] What value system does this create, if prisoners don't have capital, or friends and family who show up for them? What economy of self-worth does this construct? Is representation really an affirmation of individual freedoms, or another form of subjection?

Like the 'click clicks', the photographs in *Prison Landscapes* are also taken by and of inmates. While posing for their portraits, they are allowed to make gestures of their choosing in front of the backdrops. 'Prisoners have the freedom to kneel or sit, stand or twist to express themselves through their body even through their facial expressions and sometimes their clothes, depending on how restricting their dress code is in the institution,' Emdur told me. 'There are still a lot of decisions that the inmates are making within that frame to express themselves.'[22] Even the slightest of physical gestures can begin to dissolve the edges of institutional control. Alongside kneeling and crouching and even touching the backdrops, some hold props that relate to the scene they stand in front of, such as fake fish when the mural is of a lake or river. Although such gestures give the appearance of physical freedom, Emdur explains that the photographs are still governed by the prison authorities. 'This photographic system is so controlled,' she said, 'in the sense that the prison is saying, this is a painting you can only get your photograph taken in front of, and we're going to crop out everything outside the frame. That is so oppressive and restricting in terms of representing yourself.'[23]

With Emdur's critique in mind, I wondered whether the fantastical murals also perpetuate yearning, or a false sense of hope? What role might shame, or denial, play in an inmate's

preference to be photographed in front of a beach or city street, rather than to share with those on the outside the reality of their incarceration? Emdur told me that 'the backdrops are definitely all about escapes, about pretending that one is "someplace else"'.[24] Yet what is the emotional potency of fantasising about escape – and what is its relationship to melancholy? Within the confinements of prison, the self can easily fragment, and feelings of hopelessness and isolation can ignite. In such conditions, perhaps fantasising is a coping mechanism.

If we consider the isolating nature of prison, the painted backdrops could be perceived as a mode of regaining control for inmates, when they have been cast off and rendered abject by the state. The abject self, Julia Kristeva writes, 'is not me, it is a non-me, beside me, outside of me, where the me becomes lost'.[25] For Kristeva, abjection 'disturbs identity, system, order'.[26] The murals seem dually to work against abjection while retaining symptoms of it. The identity prescribed to prisoners by the penal system – the 'non-me, besides me' – is one that dismantles their control and agency. Yet the murals also offer a semblance of freedom by fictionalising agency: in this way they are abject while also rejecting abjection; alienating yet liberating; images that resist the melancholic, limbo state which they also epitomise. They demonstrate the 'not I' or 'not me' that prison imposes, but also the me that is here, posing in front of a mural.

*

One day, while researching *Prison Landscapes* online, I found a magazine interview published in June 2012 in *The Atlantic*, just before Emdur's book was launched. In the interview Emdur explains to the journalist that when it comes to the murals, 'fantastical scenes are actually much less common – from what I gather from my correspondence, realism is like gold in prison'.[27] I wondered what the significance of realism was – and why, for

example, beach landscapes were abundant, but sci-fi worlds were not. Is the desire to be depicted 'realistically' bound to a feeling of misrepresentation or loss of agency? Art history refers to realism as having veracity to a real life object, place or person. In Prison Landscapes, inmates both desire backdrops which remind them of the outside world, and places they remember, alongside fantasy landscapes which transport them elsewhere. The combination of both demonstrates the dual need for a connection to reality, and visual signifiers of freedom. This tension, between the real and imagined, is a knot which only gets tighter and more urgent the further the incarcerated are denied visual recognition.

I didn't contact prisoners to request hard copies of the mural photographs – I was acutely cognizant of the fine line between 'research' and voyeurism, and wary of infringing upon a terrain which wasn't mine to explore. But in Santa Fe, New Mexico, I did see some murals in the flesh. The Old Main Prison, a closed correctional facility located south of Santa Fe, a short distance from State Road Fourteen, resides in managed decay, adjacent to the Sangre de Cristo Mountains – an otherworldly backdrop. The prison closed after the infamous 1980 prison riot, where for over 36 hours prison officers were held hostage, tortured, and mutilated with construction tools, and 33 inmates died.

Since then, the Old Main Prison has remained derelict for over 30 years. In 2013 it reopened to the public for 2-hour tours run by the New Mexico Correctional Division (NMCD), capitalising on its reputation for western-esque ghost stories and eerie architecture. ('Respecting our past to create a better future', as the NMCD website puts it.) For a mere $20 you can embark upon some of the most brutal moments in US penal history – one in which prison murals feature. I signed up to a tour, and a week later took the 40-minute drive south from Española to the rugged orange sands of Santa Fe County.

Old Main is a panopticon style facility, comprising of a pale

pink watchtower, extensive cells and long corridors, all of which create a melancholy sense of oppression. The entrance functions as a museum and shop: on display are the weapons used in the riot, the hats of the prison guards who were murdered, and tourist t-shirts for sale. Aesthetically, the t-shirts mimic the traditional orange, white, and black of US prison jumpsuits, and were oversized, with v necks and short sleeves. They hung in the entrance window, acting as relics of the prison, demonstrating how the tour capitalises from its reputation and legacy. In the main entrance, a cabinet displays test tubes of small weapons uncovered after the riot, including shards of glass wrapped in flannels and tiny spears. There are also officer hats and batons, badges and whistles, and photographs of the prison prior to the riot. Further inside, the elongated corridors are littered with graffiti, eroding concrete, and cell bars covered in peeling paint. On the tour I couldn't help but think of the gross obsession with decay porn. But I was here 'to view the paintings', I kept telling myself; to feel their complicated role in the representation and expression of prisoners.

There are two murals in Old Main. The first, located in the dining hall and covering the entirety of the south facing wall, depicts a woman with her arms spread over two flowing barrels of fruit and vegetables. Two figures stand by her side wearing headdresses, pensively staring outwards. All three women are characterised in aggressive purples, pinks, and blues. Yet behind them a yellow sunset creates an atmosphere of utopia – a feeling of transformation, movement. In contrast to the decaying walls, the mural felt like the only part of the prison that had survived. In the visitation room is a brightly coloured scene of a river and mountains. The painting is reminiscent of fluvial valleys I have visited while hiking the Big Costilla Peak in the Culebra Range in Northern New Mexico and the state line of Colorado. Even when I'd been to this mountain range in the blistering summer, there was a palpable feeling of misplacement, a vastness so

incomprehensible it became almost fantastical. The mural also felt visually aligned with the natural scenes captured by Emdur: there was a strange, pensive feeling to the not-quite realistic landscape.

*

During my visit, most of the facts shared by the tour guide passed me by, but after I left, driving north towards Santa Fe, his uncanny concluding words rang in my head: 'We remember the deaths through the building, but there are no photographs or pictures of those who died.' There were no portraits of the inmates or guards. Instead, the building had itself come to represent the criminal violent legacy; a place that had consumed and erased those whose lives it once contained.

Visiting Old Main made the collective effort of *Prison Landscapes*, and the attempt to provide prisoners with a means of presenting themselves in association with places and atmospheres outside of the prison, all the more pertinent. bell hooks claims that 'beginning with love as the ethical foundation for politics... we are best positioned to transform society in ways that enhance collective good'.[28] Love and compassion, hooks reminds us, can be political too, and collective action can function as a tool of resistance against isolation. Prison Landscapes, Emdur told me, is 'about seeing prisoners through the eyes of their loved ones and not through the typical lens of criminality'.[29] Talking to her, I got the feeling that she believed we live in a time where, more than ever, solidarity is something that must be insisted upon and instigated, a position which demands to be revisited time and time again, until we find alternative avenues of representation for the marginalised.

Forensic Sketch Artists

The problem is not that people remember through photographs, but that they remember only the photographs...Narratives make us understand. Photographs do something else: they haunt us.
Susan Sontag

After reading an article in October 2017 on the website Forensicmag.com, 'Face of 313-year-old Scottish "Witch" Reconstructed', Sontag's words truly resonated. At the top of the page, a forensic recreation of a woman named Lilias Adie stared back at me, and I felt haunted by someone I had never met. Her face hovered against a black setting and her expression was guarded and cautious, as if she was focusing upon something in the distance, something unattainable: an impalpable moment in history. As I read on, I discovered that Adie was imprisoned after confessing to being a witch and having sex with the devil, and that she died in 1704 in her cell before her body could be publicly burned by authorities for her crimes.

The image of Adie made a troubling impression on me. Partly because of the strange, blank context in which she had been placed, but mostly because of the circumstances in which the portrait was constructed. Adie's skull was sent to the University of St Andrews in Scotland over a century ago in order to be photographed and documented. The skull subsequently went missing, but photographs of it are kept at the National Library of Scotland. In 2017, her skull was recreated by Dr Christopher Rynn in the Centre for Anatomy and Human Identification at the University of Dundee using 3D virtual sculpting techniques, technology that also allowed researchers to approximate her skin tone and facial likeness.

The resulting portrait serves as a poignant example of how

forensic art can be applied to the past. Rynn was quoted in *The Telegraph* explaining the uncanny intimacy inherent to this method of artistic creation: 'it's a bit like meeting somebody and they begin to remind you of people you know, as you're tweaking the facial expression and adding photographic textures'.[1] His comment, and the model of Adie's head, raised important questions: what does it mean to depict someone outside of a historical context, and in their absence? Perhaps I found the image on the website unnerving because any act of remembering Adie, or mourning her death, could only take place in relation to her face, rendered in the blank, nondescript language of forensic technology – a language developed by the descendants of the same legal authorities who sought to erase her by sentencing her to public execution.

One of the things I find most intriguing about forensic modelling is the way in which unknowable parts of another's life are amplified. Today, image modification/identification, composite imagery, E-FITS and post-mortem drawings are all methods used by law enforcement to apprehend or identify those who cannot be found physically. In this economy of speculative images impressions are presented as facts. Yet contained within any single forensic image are two different notions of the body: the body that is lost, either missing or wanted or dead, and the body produced by the imagination of the forensic artist. Such an image may perform a third function too, acting as a public memorial to those who are otherwise untraceable. In the law and order context in which forensic portraits are often circulated, it is easy to forget that they are created by individuals and are therefore vulnerable to human biases.

When forensic artists compose portraits of suspected perpetrators for the police, they are based upon physical descriptions given by witnesses, DNA, and the findings of anthropologists – if bone remains can be obtained. Often the artist will interview the witness or victim in person to gain a first-hand

account of their experience. The International Association for Identification website is used by over 7000 professionals around the globe, and offers information on training, professional conduct, certifications, and committees. The Code of Ethics and Standards of Professional Conduct provide guidelines for forensic artists. For instance, clause 1.02 calls for 'full and fair examinations in which conclusions are based on evidence and reference material relevant to the evidence, not on extraneous information, political pressure, or other outside influences'. Clause 1.06 continues the theme of maintaining a dispassionate and objective distance from the subject, requiring that artists report 'to appropriate officials any conflicts between his/her ethical/professional responsibilities'.[2]

But can forensic artists abide by these guidelines? Not only is pure objectivity often beyond us as humans, it is also not what motivates most of us to action. Lois Gibson is a case in point. Described by The Guinness Book of World Records as 'the world's most successful forensic sketch artist', she has helped solve over 750 cases. But as her story demonstrates, biases are not merely a factor in certain cases: they may be present in the very reasons a person joins the profession to begin with. 'Her near-death experience as the victim of a serial rapist/killer fuels her passion for catching criminals,' her website states, explaining that Gibson decided to take up the trade owing to a personal trauma.[3] As both sympathiser and victim herself, it seems unlikely that clause 1.02, and its direction to 'ignore outside influences,' could ever be a rule she followed.

Forensic art's end product – whether a sculpture or image – is always a strange combination of factual scientific data and speculation. As an art form, it is wide open to personal prejudices and demographic profiling. In 'Giving Remains a Face', a video produced by the television channel News 12, sketch artist Kelly Lawson discusses the emotional and practical elements of her job. Over footage of Lawson in her studio at the Georgia Bureau

of Remains holding a skull – 'not a replica', the viewer is told, 'but the *actual* skull' – a narrator announces that 'these people were real people, they had spirits, they had real personalities', but that 'who they really are, is a mystery'. Lawson proceeds to demonstrate her process, which involves attaching markers to the skull, and then applying clay to shape the face. 'I don't know sometimes,' she says, 'I just feel like this person had green eyes, so you go with it.'[4] The honesty on Lawson's part is striking, and shows just how susceptible to change our identities are when produced through the eyes of others.

*

In the world of online forensic resources, there are government websites that function as archives of 'missing persons' for those whose physical status remains precarious. The Georgia Bureau of Remains (GBR), where Lawson works, is run by the State of Georgia's Bureau of Investigation. It was launched in 1940, with the intention of operating as a site of exposure, archive, and evidence, where the public can come to view photographs of the missing. The GBR archive is comprised of sketches, photographs, and models. While some individuals have substantial case files, many are only accounted for with a description of the last place they were seen. Scrolling through the entries feels like looking at an old-fashioned government website from the late 1990s. Six pages of clay sculptures and drawings demonstrate the spectral territory forensic portraits occupy, between lost and found. I often found myself thinking about shame while writing this book, in between bouts of extreme nausea and discomfort at some of the material I've encountered. Grinding my teeth, and feeling physically affected, I realised I was experiencing waves of anxiety over how I could present my findings in a way that does not further erase, subjugate, or define against their will subjects who may have already suffered that fate at

the hands of the legal system. After all, there is a parallel that can be drawn between writing about forensic portraits and making them. Both oblige an artist or writer to take ethical responsibility when trying to accurately represent the subject in question. And, when it comes to representing the identities of the incarcerated, a writer must take note of the bleak history of encroachments upon, and manipulations of, the body of the prisoner. In his book *Discipline and Punish: The Birth of the Prison* (1977), Michel Foucault introduced the idea of the production of the 'docile body' within the prison system, as 'one that may be subjected, used, transformed, and improved'.[5] Such a body, Foucault argued, 'can only be achieved through a strict regimen of disciplinary acts'. To improve a prisoner, to mould them into a particular image, the prison system must take from them their right to choose when, how, and if they wish to be seen, by enforcing a regime of compulsory surveillance. As such, any act of representing or viewing images of prisoners, or the wanted, is necessarily fraught.

The voyeuristic consumption of criminality in popular media also indicates that we watch, read, and discuss crime in part out of morbid curiosity, while also enjoying the political and intellectual dilemmas the genre of 'crime entertainment' raises. This is exemplified by the popular fascination with Ted Bundy, who murdered at least 30 women in the US in the 1970s across a 5-year span. In 2019 his life was made into a Netflix documentary: *Conversation with a Killer: The Ted Bundy Tapes*. (This is one of many documentations of Bundy – there are endless biographies, documentaries, and articles.) During the trial, Bundy – a white, charismatic man and former law student – acts as his own legal defence. Biographer Ann Rule, author of *The Stranger Besides Me* (2008), defines Bundy as 'a sadistic sociopath who took pleasure from another human's pain'.[6] Perhaps because of his sadistic charisma, or the magnitude of his gruesome crimes, the trial captured the imagination of many

– particularly women. Some even went to watch him in court. In the documentary, one woman, when prompted by a journalist, admits she doesn't 'know why she's so fascinated with Bundy', yet keeps turning up to watch. The latest documentary, much like the spectacle of the trial, further perpetuates the voyeuristic consumption of violence against women, while giving Bundy the attention he wanted: he is portrayed as a blood sucking werewolf on the loose, hungry for women's bodies, fame, and control. It felt important to ask myself difficult ethical questions about my own position, interest, and intent. Given the popularity of 'crime voyeurism' in cultural production, I was mindful that my own writing didn't contribute to the problem. Because of this, I approached the GBR website cautiously, as it seemed to sit in an ambivalent territory: an unsettling archive of those who might never be found, and a testament to the government's blunt treatment of bodies, archiving them in a database so public it felt almost intrusive. Scrolling through the records, one in particular stuck out: a drawing, and what appears to be a school photograph of a young black man, taken in 1978. Most other individuals only had one image, yet here were two, and I was struck by how similar the drawing was to the photograph; if I had known this individual, I certainly would have been able to recognise him from the artwork.

In *On Photography* (1977), Susan Sontag writes that:

to photograph people is to violate them, by seeing them as they never see themselves, by having knowledge of them that they can never have; it turns people into objects that can be symbolically possessed. Just as a camera is a sublimation of the gun, to photograph someone is a subliminal murder – a soft murder, appropriate to a sad, frightened time.[7]

I wondered how those depicted on the GBR website would feel about their portrayal. Would the missing man from 1978, as

Sontag suggests, feel his identity to be violated by the images that represent him in his absence? Perhaps this question is all the more pertinent today, because of the historical moment we live in: a time in which we often come to know ourselves and others intimately through visual imagery, often also feel alienated by images of ourselves, and are vulnerable to insecurities over how such depictions may function as stand-ins for our social status, history, likes, and dislikes – for our entire lives.

Looking at the gap between the drawing and photograph of the missing man, I was reminded of Julia Kristeva's reflections on states of foreignness. 'At first, one is struck by his peculiarity – those eyes, those lips, those cheekbones, that skin unlike others, all that distinguishes him and reminds one that there is someone there,'[8] she writes in her book, Strangers to Ourselves (1988). Forensic portraiture suspends an extreme state of otherness: its spectral creations remind us that 'there is someone there', as Kristeva writes, someone to look for, but that they are also someone who is yet to be found, and may never be.

*

Forensic portraits have long been a tool of legal possession. They are a concealment of identity and a record of it, a way of archiving the unseen visually, while also defining subjects through the production of images that may come to speak of, for, and over those they purport to represent. Within the extensive history of forensic identification, the work of a French police officer and biometric researcher named Alphonse Bertillon in the nineteenth century holds particular significance. Bertillon, perhaps best known as the inventor of the mugshot and anthropometry – a scientific study of the proportions of the human body – advocated recording accurate measurements of the facial features of convicts to create a system of criminal identification. Anthropometry, popularly known as the 'Bertillon system' or

'Bertillonage', consisted of three methods of identification. Firstly, the measurement of the torso, face, and limbs. Secondly, portrait parlé (spoken portrait) – a rigorous method of describing a subject through verbal description – and thirdly, photography. As such, Bertillon's contributions to the field of biometrics reduced the faces of convicts to specific features, predictions, and calculations. In the twentieth century his techniques were replaced by more 'accurate' modes of documentation, such as dactyloscopy (fingerprinting).

In England, one of the earliest and perhaps most famous examples of forensic art is a post-mortem drawing of Catherine Eddowes, the fourth of Jack the Ripper's five known victims, by City Surveyor Frederick Foster. (Eddowes was murdered the same night as another victim, Elizabeth Stride.) Foster's drawing was one of the first 'forensic' images to be captured at a crime scene, after the body was uncovered by PC Edward Watkins, at 8:30pm on 29 September 1888. It shows Eddowe's mutilated body, from which a kidney had been purposefully removed. A police surgeon named Dr Frederick Gordon Brown noted in the coroner's report that the act was performed by a person who, 'must have had considerable knowledge of the position of the organs in the abdominal cavity and the way of removing them,' which led many to believe the killer was therefore a surgeon by trade. (The murderer also took out the uterus of his second victim, and the heart of the fifth.) The supposed 'expertise' of the organ removal was hotly disputed. In 1888 the Denbighshire Press reported, 'the clever manner in which the left kidney and the other organ were removed betokened that the murderer was well versed in anatomy, but not necessarily in human anatomy, for he could have gained a certain amount of skill as a slaughterer of animals'.[9]

In a post-mortem photograph of Eddowe taken during the examination of her body, her stomach is sewn up like a repaired toy, the stitches large and roughly conducted. The photograph

and drawing have both been widely circulated in the media, books, and studies of criminality. They function as a reference point for how we archive the murdered, and for our fascination with serial killings. It is precisely the kind of material that makes me wince, as I imagine it would many who encounter it: Eddowe, sadly, is primarily remembered as a victim and a corpse. Given this legacy, it is possible to view such illustrations as a violation of selfhood, a reminder of how little say victims of violent crime have over the images that come to define them.

If contemporary forensic art has progressed in the era of digital technology, it has also extended its reach beyond a legal framework. Today, automated facial recognition techniques developed in the field of criminology have infiltrated our daily lives. Smartphones provide instant access to facial recognition software – apps like Snapchat, Instagram Stories, and FaceTime all come with it embedded. Between the late 1980s and early 1990s, a computer vision software called Eigenfaces was developed to solve emerging issues with human face recognition emerging in law enforcement identification. It was introduced to policing in the US, enabling law enforcement agencies to transfer and compare data pertaining to the human anatomy, using tools such as Elastic Bunch Graph Matching (EBGM), a programme overseen since 1993 by the National Science and Technology Council. The process allows investigators to compare two facial images using 25 points of reference, which are then scanned to determine their similarities and differences.

Today, every time we take a selfie, communicate on FaceTime, or even sign up for a Monzo bank account, we perpetuate facial recognition technology, and are often unthinkingly complicit in its use as a surveillance tool. You might have noticed the photo folder 'selfies' on your smartphone, which, if your location services are on, records the time and place your face was captured. It's considered by many to be surveillance's biggest and most horrifying tool for oppression, potentially enabling governments

to enforce authoritative control by invading the privacy of citizens. Similarly, a form of CCTV that tracks your gender and race to predict if you're likely to shoplift was launched in Tokyo in 2019, by Japanese retail technology company Vaak. In 2018, the American Civil Liberties Union (ACLU), in conjunction with close to 70 other civil rights organisations, demanded federal action to stop Amazon selling facial recognition technology.[10]

Contemporary technology can be a useful tool for identification – it permits law enforcement to search for those who are lost – but as with any method which permits data and surveillance, it raises further questions of agency, and how we are recorded against our will. I am in favour of giving a sense of closure to the friends and families of victims, but I believe the methods used in an attempt to do so also enter ethically dubious terrain: using records of travel, smartphone and internet use, CCTV footage, and DNA. The same surveillance technology is also used to infringe upon the privacy of our day-to-day lives and corrodes the margins of our civil liberties. In a 2018 Medium article, Woodrow Hartzog described the negative uses of facial technology, as an 'irresistible tool for oppression that's perfectly suited for governments to display unprecedented authoritarian control and an all-out privacy-eviscerating machine'.[11] If we can no longer escape being watched, perhaps the question we need to ask is how we want to be watched.

*

In the 1950s, the close, possessive attention paid to the criminal face took on a newly-intrusive dimension. Developments in the cosmetic surgery sector popularised the idea that appearances can be chosen and altered as we desire. Such rhetoric did not escape the criminal justice system: prison plastic surgery programmes began to emerge in North West America. The programmes were the idea of Dr Edward Lewison, a volunteer at Oakalla Prison

Farm, Burnaby, who began researching the correlation between criminals and their appearance. His study, inspired by Criminal Anthropology and conducted over a decade, suggested that unlawful tendencies are directly linked to physiognomy, and can thus be alleviated through facial reconstruction. These free, facial plastic surgery procedures invited prisoners to undergo surgery, in the hope that changing their features would alter their 'criminal' behaviour. The incentive became surprisingly popular: by 1965 Lewison had around 450 patients wanting to undergo treatment. In 1965, a prisoner serving time for Grand Larceny in Kansas State penitentiary described the procedure of having pockmarks removed to tighten his face to a reporter. 'I always cursed this face of mine,' he explained. 'It bugged me every time I shaved. It bugged me when I tried to talk to a girl. I couldn't stop thinking about it.'[12] Other healthcare professionals supported Lewison's research. In his book Prison Doctor (1975), Guy Richmond, former doctor at Oakalla prison, writes that 'correction of disfigurements, especially of the nose, might contribute towards the rehabilitation of the offender'.[13]

Lewison's research, and belief that plastic surgery was a viable method of rehabilitation, raises questions over a subject's right to their visual identity – and what we consider to be an aesthetics of criminality. What is considered to be a physical deformity, and what counts as a desirable visage? Long before Lewison, nineteenth-century criminal anthropologist Cesare Lombroso coined the term 'born criminal' to describe a predetermined link between offending and physiognomy. Lombroso believed the born criminal could be automatically identified by characteristics such as a large jaw, solitary lines in the palms, and high cheekbones. This method of recording, evaluating, and pre-judging the body has extreme racist and ableist connotations: the notion of 'the savage', and the 'physical defect', for example, go hand-in-hand with the criminal body. The ideological implications of this mode of classifying human

beings make my blood boil. Indeed, as Simone Browne argues in Dark Matters: on the Surveillance of Blackness (2015), such control 'made it possible for the black body to be constantly illuminated from dusk to dawn, made knowable, locatable, and contained within the city'.[14] What Lewison and Lombroso both failed to recognise is that difference is a positive attribute, and that 'criminality' is the result of structural and economic oppression rather than physiognomy.

By the mid-1990s the majority of Lewison's programmes had been ditched, following a human rights backlash. Yet facial stereotyping remains rife. The House I Live In, a documentary made by Eugene Jarecki in 2012, traces the relationship between the 'War on Drugs', racial profiling, and socio-economy. Jarecki filmed across the US, including in Magdalena: a small town south of Albuquerque in New Mexico with a population of less than 1,000, where policemen still wear cowboy boots, hats, and silver badges, with a thriving ranching community. In a conversation between Eugene Jarecki and Larry Clearley, a local sheriff, the extent to which profiling is still in common use is made disturbingly clear:

Larry Clearley: It's supposed to be illegal to profile, but after working so long, you kind of know who's doing something.

Jarecki Marshal: So is it sort of phoney when people say they don't profile?

LC: Oh that's all phoney, if you don't profile vehicles you're not in law enforcement, that's the way it is man, come on.

JM: Ok so what about profiling people?

LC: Profiling people? Same thing.[15]

A study in 2012 conducted in Pinellas County, Florida, shows the manner in which profiling has also infected the algorithms used in facial recognition technology. The software, which has been designed to identify a person from data, employs a similar methodology used in fingerprint analysis.

Several providers and users of facial recognition technology have been scrutinized for the racist implications of the software they disseminate. In 2003 Tech company Palantir was founded by the neo-conservative multi-billionaire Peter Thiel, and since 2013 the company's facial recognition technology has been used in New Orleans and other Southern states. In May 2019, over 140 academics at Berkeley signed a letter requesting the removal of Palantir as a corporate sponsor for the annual Privacy Law Scholars Conference – because, as Marisa Franco wrote in The Guardian, the company had been actively 'aiding the Trump administration's separation of migrant families'.[16] If we are, as James Bridle argues in New Dark Age (2018), living in a period of a new technologic metalanguage, it becomes increasingly crucial we are cognizant of who is being abused by this system. Palantir exemplifies the way in which facial recognition technology is merely an extension of a problem that predates its development; a society which favours White Americans.

If this is where the trajectory of forensic art has landed us, it is serving to entrench marginalisation further. A study published by the MIT Media Lab in January 2019 noted that recognition technology was less efficient when identifying those who are female or of colour.[17] These statistics demonstrate that due to such unreliable modes of facial recognition, those of colour become marginalised further, and are underrepresented through misidentification. In these conditions, men of colour are more likely to be branded criminal. It also permits wrongful arrests to become normalised and a regular occurrence. In further experiments on the technology led by MIT, women were mis-recognised for men 19 per cent of the time, while darker-skinned

women were mis-recognized for men 31 per cent of the time. To put this into context: if the police are dealing with a robbery, the camera footage will be matched with ten different facial recognition databases, to give authorities an indication of who might be responsible. By this measure, it is hardly a reliable tool.

Are you surprised? I imagine not really. Much of this echoes the concerns of the Occupy movement, Black Lives Matter, and other grassroots organisations fighting to expose the illegitimacy of policing. Thankfully, some people are bringing the disparities to public visibility. In 2018, Gender Shades was launched by Joy Buolamwini, founder of the Algorithmic Justice League, in order to expose facial recognition's racist and gendered tactics. In a video on the Gender Shades website, Buolamwini explains that the 'recognition [software] I was using didn't usually identify my face, unless I put on a white mask'. Buolamwini pushed this research further by creating a database of over 1000 images of people to test her suspicions. Of the companies she tested (IBM, Microsoft and Face++) all performed better on males than females, and more accurately on lighter subjects than darker subjects, failing to recognise women of colour. As Buolamwini passionately notes at the end of the video, 'if we fail to make ethical inclusive artificial intelligence we risk losing gains we made in civil rights and gender equality under the guise of machine neutrality'.[18] This lack of recognition for women and people of colour has, then, adverse effects for them. Because it allows law enforcement to assume a 'all the same' approach to policing, resulting in further incorrect arrests. There is also a broader issue of whose lives, faces, and identities are worth knowing and recording, of who gets protected by the law. In light of the research conducted by Buolamwini and MIT, there is no reason to believe that anything other than biased algorithmic policing and surveillance is taking place. Facial recognition doesn't just document the faces of those it encounters; it places them in a pyramid of risk and worth.

Heather Dewey-Hagborg and Chelsea E. Manning, *Probably Chelsea*, 2017; Genetic materials, custom software, 3D prints; 30 portraits, each portrait 8 x 6 x 8 inches, overall dimensions variable. Courtesy of the artists and Fridman Gallery.

Heather Dewey-Hagborg, *Radical Love*, 2016; Genetic materials, custom software, 3D prints, documentation; each portrait 8 x 6 x 6 inches. Courtesy of the artist and Fridman Gallery.

Radical Love: A Conversation with Heather Dewey-Hagborg

While researching facial recognition techniques and uses of DNA, I emailed Heather Dewey-Hagborg, an artist whose work exposes the dangers of data collection and identity. By mimicking the processes undertaken by law enforcement – primarily, producing portraits based upon DNA samples collected from strangers – she creates images that stand in resistance to surveillance. For *Stranger Visions* (2012-2013), she collected cigarette butts and chewing gum to create composite portraits of strangers. Dewey-Hagborg began communicating with Chelsea Manning in 2015, when she was incarcerated in Fort Leavenworth, with the intention of creating – much like Alicia Neal's portrait – an alternative public representation of her. Given the circumstances, using forensic methods of representation seemed appropriate: Manning's gender status had been denied by the prison system, she had been misrepresented visually and physically, and through her incarceration she had, in her own way, been rendered a missing person.

After communicating via mail, Manning sent Dewey-Hagborg hair clippings and two swabs which she placed in a plastic fruit punch bag from the Joint Regional Correctional Facility at Fort Leavenworth. Together, they decided to create two portraits: one to reflect Manning's female gender, and one gender neutral image intended to demonstrate the reductionism of forensic recognition. Their collaboration materialised as a form of activism, and Dewey-Hagborg was delighted to generate visibility for Manning while subverting algorithmic systems of facial recognition and portraiture. What emerged were two portraits collectively titled *Radical Love* (2015). They function as a homage to Manning, while also dismantling genetic data as absolute, restating that it is our liberty and right to represent

ourselves how we see fit. Probably Chelsea, a series of 30 different portraits of Manning created from DNA analysis in 2017 and exhibited at Fridman Gallery, New York, is an extension of Radical Love.

Dewey-Hagborg's portraits seek to uncover the dominant narratives surrounding who is considered eligible and worthy of representation, and who is deemed the author of their own image, while shaking off outdated notions of genetic essentialism. They also demonstrate how solidarity with the incarcerated can begin with a single strand of hair.

*

Phone interview conducted between Hatty Nestor and Heather Dewey-Hagborg, January 2018 between New Mexico and Berlin.

Hatty Nestor: The constraints placed upon Chelsea Manning while she was in prison meant that she had little control over her identity or the distribution of her portrait. As an artist, what was your role in generating visibility for her through portraiture?

Heather Dewey-Hagborg: Years before I met Chelsea, I started developing this process of creating portraits of people from abandoned DNA. I would extract DNA from found genetic artefacts like cigarette butts and hair, then, using software that I wrote, I would turn that genetic information into algorithmically generated 3D portraits, which I would also 3D print in full colour, and exhibit alongside the material and the data.

In 2015 I was contacted by *Paper Magazine*, who were interviewing Chelsea through the prison mail system, and were interested in having an image to accompany the interview. At the time she couldn't be visited or photographed, and they had discussed the idea of me creating a DNA portrait. Chelsea was excited about

the concept and had read about my work before, and her only concern was that she didn't want to appear too masculine. When they contacted me, I realised that this was a great opportunity to both pay homage to Chelsea Manning, whose heroism I admire, and also to use the technology for good, by giving her the public face that had been taken from her. And, simultaneously, in a kind of double gesture, to deconstruct this technology itself, to call attention to some of its shortcomings and reductions.

HN: What was the process of removing Chelsea's DNA from prison?

HDH: I hadn't met Chelsea in person. She collected some hair clippings when she was getting her haircut. She also took two Q-tips and swabbed the inside of her mouth, and mailed these from prison to her lawyer. Then the lawyer sent me a Fed-Ex envelope with the materials. At the time I was working at a lab at the Art Institute of Chicago.

With the early portraits I made, I wanted to show the reductionism around gender and sex in particular. After the first portraits commissioned by Paper Magazine in 2015, the prints were exhibited at the World Economic Forum in 2016, after which Chelsea and I stayed in touch, and worked together on a short graphic short story called 'Suppressed Images 2016' that we published as part of her clemency campaign. In the comic we forecast the idea of Obama commuting her sentence, and Chelsea being freed and being able to come and see an exhibition of portraits of herself for the first time. We published the comic on the morning of 17 January, and then that afternoon Obama commuted her sentence. It was an unbelievable and emotional experience.

After that we began developing ideas, drawing on Chelsea's writing, and the discussions we'd had in our letters about reductionism and biometric portraiture. Our ideas addressed

ancestry and the social construction of race, what else can be done with this kind of technology, and how to use it proactively. This led to the idea of showing even more variations of her portrait, to demonstrate just how subjective the interpretation of DNA data is, and how diverse she could look based on the same information.

HN: The first portraits were a pair called *Radical Love*. After this, you made *Probably Chelsea*: 30 portraits of Chelsea, which are all aesthetically different, exhibited in 'Becoming Resemblance' at the Fridman Gallery, New York. Looking at them initially you wouldn't necessarily say they're reconstructions of the same subject. They show how identity isn't necessarily fixed to a single outer appearance or prescribed gender.

HDH: The portraits are about exploding outmoded ideas of biologically inscribed identity, refuting stereotyped representations of phenotypical characteristics, and using a scientific and data-driven process to show how many different readings there are of the same data.

HN: How were the portraits received? Do you think you raised the questions that you wanted it to, about gender and the prison-industrial complex?

HDH: *Radical Love* premiered at the World Economic Forum in January of 2016, if I remember correctly. That, especially from an activist angle, was a practical place to begin. The later work, *Probably Chelsea*, in a way is a kind of celebration. It's a celebration of Chelsea's release. It's a celebration of the genetic commonality that we all share. In a sense it's much lighter and more playful and fun. It's more of an art installation, and also an opportunity for Chelsea to enter into being an artist, and being seen as an artist. In answer to the question, the reception has been positive.

The new piece with the 30 portraits is just beginning to travel, so let's see what kind of impact it has. It's a little too early to say since we've only shown it once for the opening in New York. Now it'll go to Berlin, and Frankfurt, and all over the place after that. So let's see what kind of impact that has.

HN: It seems crucial to consider how *Radical Love* aids Chelsea's visibility and representation now that she has more control over it. There was a fantastic release of images of her in Vogue in August 2017, for example, where she is wearing a black sweater and standing against a wall. Your early portraits act as an archive of what wasn't possible, and I wonder how their purpose has changed.

HDH: *Radical Love*, the two portraits, served as a kind of document of their time. The 30-portrait piece, *Probably Chelsea*, was always something different. It was meant to be shown after she was released, and was expected to be an exploration of different kinds of ideas around identity and challenging identity inscription. It was always intended for her to see upon being free.

Acknowledgements

I'd like to thank everyone at The Royal College of Art for their unwavering support throughout my studies. Without their invaluable guidance, kindness, and brilliance I am certain this book would never have come to fruition. I am also indebted to those who allowed me to interview them, and who shared their experiences of the justice system.

Several people have contributed to the conceptualisation of this book. Notably Gabriel Duckels, whose sharp mind continually astounds me. James Wreford, for his generosity and brilliant take on true crime. Jackie Wang and her profound foreword, and general intellectual and writerly advice. And Rosanna McLaughlin, whose astute editorial work made this book miles better than I could have ever anticipated. Thank you.

Thank you to Ed Gillman, The Arts Council England, Jerwood Arts, and Zero Books for supporting my growth as a writer. And to *The White Review*, where an early version of Facing Future Feelings: The Portrait of Chelsea Manning appeared in Issue 21. Finally, to friends who have shown fierce support and encouragement; Claire Liddiard, Abi Andrews, Jay Drinkall, James Pogue, Ben Thomas, Rachel Hill, Alex Quicho, Sim Gray, and Finn McKenna. And finally, to my Mum, whose passion for life never ceases to prevail.

Endnotes

Introduction

1. When the protagonist of Breaking Bad, Walter White, died in 2013, his character was mourned in New Mexico. The Albuquerque Journal published an obituary for him, and many attended a mock funeral for him in Albuquerque Sunset Memorial Park. According to Maxim, for $20 attendees received 'two silicone bracelets imprinted with Walter White's name, and a handful of dirt to help "bury" the deceased'; tickets to the funeral raised $1700 for the homeless. What does this say about a society, if the death of a fictional character is better remembered, and attracts more money, than a living citizen in need?

Facing Future Feelings: The Portrait of Chelsea Manning

1. Black and Pink, *Coming Out of Concrete Closets* (2015) <https://www.blackandpink.org/wp-content/upLoads/ Coming-Out-of-Concrete-Closets.-Black-and-Pink.- October-21-2015..pdf> [accessed 11 February 2017].
2. Baudewijntje P. C Kreukels, Thomas D Steensma, and Annelou L. C. de Vries, *Gender Dysphoria And Disorders Of Sex Development* (New York: Springer, 2014), p 12.
3. Joey L. Mogul, Andrea J Ritchie, and Kay Whitlock, *Queer (In)Justice: The Criminalization of LGBT People in The United States* (Boston, Massachusetts: Beacon Press, 2012), p. 117.
4. Paul Lewis, 'Bradley Manning supervisor "ignored photo of soldier dressed as woman"', *The Guardian* (2013) <https:// www.theguardian.com/world/2013/aug/13/bradley- manning-email-drag-photo-sentencing> [accessed 9 January 2017].
5. Martha Sorren, 'Chelsea Manning Reveals Gender Identity;

97

Army Unlikely to Grant Hormone Therapy Request', *Truthout* (2013) <https://truthout.org/articles/chelsea-manning-reveals-gender-identity-army-unlikely-to-grant-hormone-therapy-request/> [accessed 15 February 2017].

6. Sandra Bland, who was found supposedly hanged in her cell in Waller County Texas on 13 July 2015, was another racially charged case which spread like wildfire throughout the activist network Black Lives Matter. Bland's death was ruled to be a suicide: this conclusion was taken with scepticism by activists, following the release of video footage taken by a bystander of Bland being kneeled on by her car, the fact that no photographs of her hanging in the cell were ever provided (the jail authorities claimed she was hung by a trash bag), and that CCTV footage showed the gurney leaving prison without her body on it. The main representation of Bland in the media was taken from her Linkedin profile alongside the mugshot taken by the correctional division. It has also been speculated upon by activists and among the media that Bland may have already been dead when the authorities took her mugshot. Since 2015 alternative images have become available, which can be found via a simple Google search.

7. Author interview with Alicia Neal, illustrator, 16 January 2017.

8. Ibid.

9. Ibid.

10. Chelsea Manning, 'Solitary Confinement Is "No Touch" Torture, And it Must be Abolished', The Guardian (2016) <https:// www.theguardian. com/world/ commentisfree/2016/ may/02/solitary- con nement-is- solitary-con nement- is-torture-6x9-cells- chelsea-manning-no-touch-torture-and-it-must-be-abolished> [accessed 11 January 2017].

Negotiating Empathy: Courtroom Artists

1. It's also important to note that court sketches are symptomatic of the US legal system's relationship with capital. For instance, those who can afford a better defence are frequently not prosecuted or are treated with greater leniency. In this vein, it's possible to say that 'justice' is dependent on a superior socio-economic position. Those often depicted in courtroom sketches will have a large sum of money attached to their case in terms of the witness, and even on behalf of the state.

2. Harriet Alexander, 'Taylor Swift's courtroom sketch artist says he struggled to draw her because she was too pretty', *The Telegraph* (2017) <https://www.telegraph.co.uk/news/2017/08/15/taylor-swifts-courtroom-sketch-artist-says-struggled-draw-pretty/> [accessed 12 September 2017].

3. Chris Chase, 'Tom Brady's courtroom sketch is hilarious horrible', *USA Today* (2015) <https://ftw.usatoday.com/2015/08/tom-brady-courtroom-sketch-deflategate-hearing-patriots-awful> [accessed 15 January 2017].

4. Megan Lane, 'A day in the life of a court artist', *BBC* (2004) <http://news.bbc.co.uk/aboutbbcnews/hi/news_update/newsid_3866000/3866845.stm> [accessed 8 December 2016].

5. Helier Cheung, 'Taylor Swift's court sketch: a misunderstood art', *BBC* (2017) <https://www.bbc.co.uk/news/world-us-canada-40909553> [accessed 12 September 2017].

6. Richard Price and Jonathan T. Lovitt, 'Confusion for Simpson's kids "far from over"', *USA Today* (1997) <http://usatoday30.usatoday.com/news/index/nns224.htm> [accessed 12 July 2019].

7. Arlie Russell Hochschild, *The Managed Heart* (Berkeley: California University Press, 2012) p. 89.

8. Steve Robson, 'Artist makes history by becoming first person allowed to draw sketches inside court', *Mirror* (2013) <https://www.mirror.co.uk/news/uk-news/artist-makes-

history-becoming-first-2359199> [accessed 1 June 2019].

9. I interviewed Coleman in November 2016 in The Whitechapel Gallery, London.

10. *Proposals to allow the broadcasting, filming, and recording of selected court proceedings,* Ministry of Justice (London: Ministry of Justice, 2012) p. 9. <https://www.gov.uk/government/uploads/system/uploads/attachment_data/file/217307/broadcasting-filming-recording-courts.pdf> [digital version, accessed 12 January 2017].

11. *Criminal Justice Act* (1925), p. 34 <http://www.legislation.gov.uk/ukpga/1925/86/pdfs/ ukpga_19250086_en.pdf> [digital version, accessed 06 February 2017].

12. Author interview with Priscilla Coleman, courtroom artist, 29 November 2016.

13. Ibid.

14. Naomi Murakawa 'Weaponized Empathy Emotion and the Limits of Racial Reconciliation in Policing' in *Racial reconciliation and the healing of a nation.* Ogletree, C. and Sarat, A (New York: NYU Press, 2017), p. 108.

15. Leslie Jamison, *The Empathy Exams* (London: Granta, 2014), p. 23.

16. Author interview with Priscilla Coleman, courtroom artist, 29 November 2016.

17. Roman Krznaric, *Empathy: Why It Matters, and How to Get It* (New York: Perigee Books, 2014), p. X.

18. Judith Butler, *Precarious Life*, 2nd ed. (London: Verso, 2006), p. 134.

19. Author interview with Priscilla Coleman, courtroom artist, 29 November 2016.

20. 'Criminal Cases', *Open Justice* (2016) <http://open.justice.gov.uk/courts/criminal- cases/> [accessed 22 April 2017].

21. Elizabeth Williams, and Sue Russell, *The Illustrated Courtroom: 50 Years of Court Art* (New York: CUNY Journalism Press, 2014), p. 68.

22. Author interview with Priscilla Coleman, courtroom artist, 29 November 2016.

23. Ibid.

24. Sara Ahmed, *The Cultural Politics of Emotion* (New York: Routledge, 2004), p. 4.

25. Author interview with Priscilla Coleman, courtroom artist, 29 November 2016.

26. Russell Hochschild, *The Managed Heart*, p. 82.

27. Author interview with Priscilla Coleman, courtroom artist, 29 November 2016.

Where Accountability Lies

1. Jeff Greenspan and Andrew Tider, 'Captured: People in Prison Drawing People Who Should Be', *The Captured Project* (2016) <https://thecapturedproject.com/> [accessed 17 March 2017].

2. All profits from the book were used to support the presidential campaign of Vermont Senator Bernie Sanders, in 2016.

3. Author interview with Jeff Greenspan, artist, and Andrew Tider, artist, 18 February 2017.

4. Ibid.

5. Ibid.

6. Citigroup, 'Citi Discloses Results of Investigation into Security Unit in Mexico', *Citigroup* (2014) <https://www.citigroup.com/citi/news/2014/141014b.htm> [accessed 14 March 2017].

7. Propublica, *Citigroup* (2013) <https://projects.propublica.org/bailout/entities/96-citigroup> [accessed 20 March 2017].

8. Jackie Wang, *Carceral Capitalism* (New York: Semiotext(e), 2018), p. 131.

9. Blair Erickson, 'How is a corrupt criminal like Jamie Dimon, not in prison for fraud?', *Medium* (2017) <https://medium.com/@blairerickson/how-is-a-corrupt-criminal-like-jamie-

dimon-not-in-prison-for-fraud-f3a1e7eb4cf6> [accessed 12 October 2017].

10. Author interview with Jeff Greenspan, artist, and Andrew Tider, artist, 18 February 2017.

11. Ibid.

12. Nancy Fraser, 'Recognition Without Ethics', in ed. by Marjorie Garber Beatrice Hanssen and Rebecca L Walkowitz, *The Return to Ethics* (New York and London: Routledge, 2000), p. 100.

13. Author interview with Jeff Greenspan, artist, and Andrew Tider, artist, 18 February 2017.

14. Jeff Greenspan and Andrew Tider, 'Captured: People in Prison Drawing People Who Should Be'.

15. Author interview with Jeff Greenspan, artist, and Andrew Tider, artist, 18 February 2017.

16. Ibid.

Prison Landscapes

1. Alyse Emdur, *Prison Landscapes* (London: Four Corners Books, 2012), p. 2.

2. Karen M Morin and Dominique Moran, *Historical Geographies of Prison* (Abingdon, Oxon: Routledge, 2015), p. 142.

3. Larry Brewster, 'the Impact of Prison Arts Programs on Inmate Attitudes and Behaviour: A Quantitative Evaluation', *Justice Policy Journal*, Volume 11, Number 2 (Fall), pp. 1-28 [Online]. Available at <http://www.cjcj.org/uploads/cjcj/documents/brewster_prison_arts_final_formatted.pdf> [accessed 25 March 2019].

4. Author interview with Alyse Emdur, artist, 3 February 2017.

5. Ibid.

6. Ibid.

7. Ibid.

8. Ibid.

9. Ibid.

10. Websites such as prisonphotography.com seek to provide an outlet for the representations of those incarcerated to be discussed and documented. Sites like this demonstrate that there is a collective resistance to how prisoners are represented to the outside world.

11. Author interview with Alyse Emdur, artist, 3 February 2017.

12. Kristen S Wilkins, 'Supplication, Photo Series - Kristen S. Wilkins', *Kristen S. Wilkins* (2019) <https://www.kristenwilkins.com/supplication#10> [Accessed 10 March 2019].

13. Author interview with Alyse Emdur, artist, 3 February 2017.

14. Ibid.

15. Wang, *Carceral Capitalism*, p. 361.

16. Author interview with Alyse Emdur, artist, 3 February 2017.

17. Ibid.

18. Conversations in NCV visitations are often recorded by prison authorities, who have the permission to listen back to the conversations. It is mandatory that the prison records all conversations between visitors, inmates, and operators.

19. Emdur, *Prison Landscapes*, p. 3.

20. Author interview with Alyse Emdur, artist, 3 February 2017.

21. These photographs are often between $2 -$3 – another method of how the justice system gains capital from prisoners.

22. Author interview with Alyse Emdur, artist, 3 February 2017.

23. Ibid.

24. Ibid.

25. Julia Kristeva, *Revolution in Poetic Language* (New York: Columbia University Press, 1984), p. 86.

26. Julia Kristeva, *Powers of Horror: An Essay on Abjection*, translated by Leon S. Roudiez (New York: Columbia University Press, 1982), p. 4.

27. Nicola Willey, 'Captive America: An Interview With Alyse Emdur', *Venue* (2012) <http://v-e-n-u-e.com/Captive-

America-An-Interview-with-Alyse-Emdur> [accessed 11 March 2017].

28. bell hooks, *Outlaw Culture: Resisting Representations* (New York and London: Routledge, 1994), p. 294.

29. Author interview with Alyse Emdur, artist, 3 February 2017.

Forensic Sketch Artists

1. Telegraph Reporters, 'Face Of "Witch" Who Died Before She Could Be Burned For Her "Crimes" Is Digitally Reconstructed 300 Years Later', *The Telegraph*, 2017 <https://www.telegraph.co.uk/news/2017/10/31/face-witch-died-1704-digitally-reconstructed/> [Accessed 11 February 2019].

2. International Association for Identification, Code of Ethics and Standards of Professional Conduct (2018) <https://theiai.org/docs/code_of_ethics.pdf> [accessed 10 February 2019].

3. Lois Gibson, Lois Gibson <https://www.loisgibson.com/> [accessed 13 February 2019].

4. The Art of Forensic Science (2017), YouTube video, added by Meredith Anderson. Available at <https://www.youtube.com/watch?v=1UMPqFua9sM> [accessed 26 February 2019].

5. Michel Foucault, *Discipline and Punish*, translated by Alan Sheridan, 2nd ed. (New York: Vintage Books, 1977), p. 136.

6. Anne Rule, *The Stranger Beside Me* (New York: Pocket Books, 2009), p. XIV [Online]. Available at <https://books.google.co.uk/books?id=sWPBQQ5vl2MC&pg=PR14&dq=a+sadis-tic+sociopath+who+took+pleasure+from+another+human%-27s+pain+ann+rule&hl=en&sa=X&ved=0ahUKEwilrsqEnaj-jAhX5RBUIHfMUDXcQ6AEIKDAA#v=onepage&q=a%20sadistic%20sociopath%20who%20took%20pleasure%20from%20another%20human's%20pain%20ann%20ru-le&f=false> [accessed 11 July 2019].

7. Susan Sontag, *On Photography* (London: Allen Lane, 1978; repr. London: Penguin Classics, 2002), p. 14.

8. Julia Kristeva, *Strangers To Ourselves* (New York: Columbia University Press, 1991), p. 3.

9. Anonymous, *The London Murders* (Denbighshire Free Press, 6 October 1888), p. 6.

10. American Civil Liberties Union (ACLU), ACLU comment on Microsoft call for federal action on face recognition technology (2018) <https://www.aclu.org/press-releases/aclu-comment-microsoft-call-federal-action-face-recognition-technology?redirect=news/aclu-comment-microsoft-call-federal-action-face-recognition-technology> [accessed 14 February 2019].

11. Woodrow Hartzog, 'Facial Recognition Is The Perfect Tool for Oppression', *Medium* (2018) <https://medium.com/s/story/facial-recognition-is-the-perfect-tool-for-oppression-bc2a08f0fe6> [accessed 14 February 2019].

12. Katie Daubs, 'Change a face, change a fate: when prisoners get free nose jobs', *The Star* (2015) <https://www.thestar.com/news/insight/2015/06/28/change-a-face-change-a-fate-a-mysterious-prison-experiment.html> [accessed 1 March 2019].

13. Guy Richmond, Prison Doctor (1975), qtd. in Katie Daubs, 'Change a face, change a fate: when prisoners get free nose jobs', *The Star* (2015) <https://www.thestar.com/news/insight/2015/06/28/change-a-face-change-a-fate-a-mysterious-prison-experiment.html> [accessed 1 March 2019].

14. Simone Browne, *Dark Matters: on the surveillance of blackness* (Durham and London: Duke University Press, 2015), p. 79.

15. *The House I Live In* (2012), Directed by Eugene Jarecki.

16. Maria Franco, 'Palantir has no place at Berkeley: they help tear immigrant families apart', *The Guardian* (2019) <https://www.theguardian.com/commentisfree/2019/may/31/palantir-berkeley-immigrant-families-apart> [accessed 5 June 2019].

17. Inioluwa Deborah Raji and Joy Buolamwini, 'Actionable Auditing: Investigating the Impact of Publicly Naming Biased Performance Results of Commercial AI Products', <http://www.aies-conference.com/wp-content/uploads/2019/01/AIES-19_paper_223.pdf> [accessed 18 July 2019].

18. Gender Shade (2018), YouTube Video, added by MIT Media Lab. Available at <https://www.youtube.com/watch?time_continue=2&v=TWWsW1w-BVo> [accessed 8 June 2019].

Bibliography

Ahmed, Sara. *The Cultural Politics of Emotion* (New York: Routledge, 2004).

Alexander, Harriet. 'Taylor Swift's courtroom sketch artist says he struggled to draw her because she was too pretty', *The Telegraph* (2017) <https://www.telegraph.co.uk/news/2017/08/15/taylor-swifts-courtroom-sketch-artist-says-struggled-draw-pretty/> [accessed 12 September 2017].

American Civil Liberties Union (ACLU), ACLU comment on Microsoft call for federal action on face recognition technology (2018) <https://www.aclu.org/press-releases/aclu-comment-microsoft-call-federal-action-face-recognition-technology?redirect=news/aclu-comment-microsoft-call-federal-action-face-recognition-technology> [accessed 14 February 2019].

Anonymous, *The London Murders* (Denbighshire Free Press, 6 October 1888).

The Art of Forensic Science (2017), YouTube video, added by Meredith Anderson. Available at <https://www.youtube.com/watch?v=1UMPqFua9sM> [accessed 26 February 2019].

Author interview with Alyse Emdur, artist, 3 February 2017.

Author interview with Jeff Greenspan, artist, and Andrew Tider, artist, 18 February 2017.

Author interview with Priscilla Coleman, courtroom artist, 29 November 2016.

Black and Pink. *Coming Out of Concrete Closets* (2015) <https://www.blackandpink.org/wp-content/upLoads/Coming-Out-of-Concrete-Closets.-Black-and-Pink.-October-21-2015.pdf> [accessed 11 February 2017].

Brewster, Larrie. 'The Impact of Prison Arts Programs on Inmate Attitudes and Behaviour: A Quantitave Evaluation', *Justice Policy Journal, Volume 11*, Number 2 (Fall), pp. 1-28 [Online].

Available at <http://www.cjcj.org/uploads/cjcj/documents/ brewster_prison_arts_final_formatted.pdf> [accessed 25 March 2019].

Browne, Simone. *Dark Matters: on the surveillance of blackness* (Durham and London: Duke University Press, 2015).

Butler, Judith. *Precarious Life*, 2nd ed. (London: Verso, 2006).

Chase, Chris. 'Tom Brady's courtroom sketch is hilarious horrible', *USA Today* (2015) <https://ftw.usatoday.com/ 2015/08/tom-brady-courtroom-sketch-deflategate-hearing-patriots-awful> [accessed 15 January 2017].

Cheung, Helier. 'Taylor Swift's court sketch: a misunderstood art', *BBC* (2017) <https://www.bbc.co.uk/news/world-us-canada-40909553> [accessed 12 September 2017].

Citigroup. 'Citi Discloses Results of Investigation into Security Unit in Mexico', *Citigroup* (2014) <https://www.citigroup. com/citi/news/2014/141014b.htm> [accessed 14 March 2017].

'Criminal Cases', *Open Justice* (2016) <http://open.justice.gov.uk/ courts/criminal- cases/> [accessed 22 April 2017].

Criminal Justice Act (1925), p. 34 <http://www.legislation.gov. uk/ukpga/1925/86/pdfs/ ukpga_19250086_en.pdf> [digital version, accessed 06 February 2017].

Daubs, Katie. 'Change a face, change a fate: when prisoners get free nose jobs', *The Star* (2015) <https://www.thestar. com/news/insight/2015/06/28/change-a-face-change-a-fate-a-mysterious-prison-experiment.html> [accessed 1 March 2019].

Deborah Raji, Inioluwa and Buolamwini, Joy. 'Actionable Auditing: Investigating the Impact of Publicly Naming Biased Performance Results of Commercial AI Products', <http:// www.aies-conference.com/wp-content/uploads/2019/01/ AIES-19_paper_223.pdf> [accessed 18 July 2019].

Emdur, Alyse. *Prison Landscapes* (London: Four Corners Books, 2012).

Erickson, Blair. 'How is a corrupt criminal like Jamie Dimon, not

in prison for fraud?', *Medium* (2017) <https://medium.com/@ blairerickson/how-is-a-corrupt-criminal-like-jamie-dimon-not-in-prison-for-fraud-f3a1e7eb4cf6> [accessed 12 October 2017].

Foucault, Michel. *Discipline and Punish*, translated by Alan Sheridan, 2nd ed. (New York: Vintage Books, 1977).

Franco, Marisa. 'Palantir has no place at Berkeley: they help tear immigrant families apart', *The Guardian* (2019) <https://www. theguardian.com/commentisfree/2019/may/31/palantir-berkeley-immigrant-families-apart> [accessed 5 June 2019].

Fraser, Nancy. 'Recognition Without Ethics', in ed. by Marjorie Garber Beatrice Hanssen and Rebecca L Walkowitz, *The Return to Ethics* (New York and London: Routledge, 2000).

Gender Shade (2018),YouTube Video, added by MIT Media Lab. Available at <https://www.youtube.com/watch?time_continue=2&v=TWWsW1w-BVo> [accessed 8 June 2019].

Gibson, Lois. Lois Gibson <https://www.loisgibson.com/> [accessed 13 February 2019].

Greenspan, Jeff and Tider, Andrew. 'Captured: People in Prison Drawing People Who Should Be', *The Captured Project* (2016) <https://thecapturedproject.com/> [accessed 17 March 2017].

Hartzog, Woodrow. 'Facial Recognition Is the Perfect Tool for Oppression', *Medium* (2018) <https://medium.com/s/story/facial-recognition-is-the-perfect-tool-for-oppression-bc2a08f0fe6> [accessed 14 February 2019].

hooks, bell. *Outlaw Culture: Resisting Representations* (New York and London: Routledge, 1994).

International Association for Identification, Code of Ethics and Standards of Professional Conduct (2018) <https://theiai.org/docs/code_of_ethics.pdf> [accessed 10 February 2019].

Jamison, Leslie. *The Empathy Exams* (London: Granta, 2014).

Kreukels, Baudewijntje P. C and Steensma, Thomas D and de Vries, Annelou L. C. *Gender Dysphoria and Disorders Of Sex Development* (New York: Springer, 2014).

Kristeva, Julia. *Powers of Horror: An Essay on Abjection,* translated by Leon S. Roudiez (New York: Columbia University Press, 1982).

Kristeva, Julia. *Revolution in Poetic Language* (New York: Columbia University Press, 1984).

Kristeva, Julia. *Strangers to Ourselves* (New York: Columbia University Press, 1991).

Krznaric, Roman. *Empathy: Why It Matters, and How to Get It* (New York: Perigee Books, 2014).

Lane, Megan. 'A day in the life of a court artist', *BBC* (2004) <http://news.bbc.co.uk/aboutbbcnews/hi/news_update/newsid_3866000/3866845.stm> [accessed 8 December 2016].

Lewis, Paul. 'Bradley Manning supervisor "ignored photo of soldier dressed as woman", *The Guardian* (2013) <https://www.theguardian.com/world/2013/aug/13/bradley-manning-email-drag-photo-sentencing> [accessed 9 January 2017].

Manning, Chelsea. 'Solitary Confinement Is "No Touch" Torture, And it Must be Abolished', *The Guardian* (2016) <https://www.theguardian. com/world/ commentisfree/2016/ may/02/ solitary- con nement-is- solitary-con nement- is-torture-6x9- cells- chelsea-manning-no-touch-torture-and-it- must-be-abolished> [accessed 11 January 2017].

Mogul, Joey L. and Ritchie, Andrea J and Whitlock, Kay. *Queer (In)Justice: The Criminalization of LGBT People in The United States* (Boston, Massachusetts: Beacon Press, 2012).

Morin, Karen M and Moran, Dominique. *Historical Geographies Of Prisons* (Abingdon, Oxon: Routledge, 2015).

Murakawa, Naomi. 'Weaponized Empathy Emotion and the Limits of Racial Reconciliation in Policing' in *Racial reconciliation and the healing of a nation.* Ogletree, C. and Sarat, A (New York: NYU Press, 2017).

Price, Richard and Lovitt, Jonathan T. 'Confusion for Simpson's kids "far from over"', *USA Today* (1997) <http://usatoday30.usatoday.com/news/index/nns224.htm> [accessed 12 July

2019].

Proposals to allow the broadcasting, filming, and recording of selected court proceedings, Ministry of Justice (London: Ministry of Justice, 2012). <https://www.gov.uk/government/uploads/system/uploads/attachment_data/file/217307/ broadcasting-filming-recording-courts.pdf> [digital version, accessed 12 January 2017].

Propublica. *Citigroup* (2013) <https://projects.propublica.org/bailout/entities/96-citigroup> [accessed 20 March 2017].

Richmond, Guy. Prison Doctor (1975), qtd. in Katie Daubs, 'Change a face, change a fate: when prisoners get free nose jobs', *The Star* (2015) <https://www.thestar.com/news/insight/2015/06/28/change-a-face-change-a-fate-a-mysterious-prison-experiment.html> [accessed 1 March 2019].

Robson, Steve. 'Artist makes history by becoming first person allowed to draw sketches inside court', *Mirror* (2013) <https://www.mirror.co.uk/news/uk-news/artist-makes-history-becoming-first-2359199> [accessed 1 June 2019].

Rule, Anne. *The Stranger Beside Me* (New York: Pocket Books, 2009), p. XIV [Online]. Available at <https://books.google.co.uk/books?id=sWPBQQ5vl2MC&pg=PR14&dq=a+sadis-tic+sociopath+who+took+pleasure+from+another+human%-27s+pain+ann+rule&hl=en&sa=X&ved=0ahUKEwilrsqEnaj-jAhX5RBUIHfMUDXcQ6AEIKDAA#v=onepage&q=a%20sadistic%20sociopath%20who%20took%20pleasure%20from%20another%20human's%20pain%20ann%20ru-le&f=false> [accessed 11 July 2019].

Russell Hochschild, Arlie. *The Managed Heart* (Berkeley: California University Press, 2012).

Sontag, Susan. *On Photography* (London: Allen Lane, 1978; repr. London: Penguin Classics, 2002).

Sorren, Martha. 'Chelsea Manning Reveals Gender Identity; Army Unlikely to Grant Hormone Therapy Request', *Truthout*

(2013) <https://truthout.org/articles/chelsea-manning-reveals
-gender-identity-army-unlikely-to-grant-hormone-therapy-
request/> [accessed 15 February 2017].

Telegraph Reporters, 'Face Of "Witch" Who Died Before She
Could Be Burned For Her "Crimes" Is Digitally Reconstructed
300 Years Later', *The Telegraph*, 2017 <https://www.telegraph.
co.uk/news/2017/10/31/face-witch-died-1704-digitally-
reconstructed/> [Accessed 11 February 2019].

The House I Live In (2012), Directed by Eugene Jarecki.

Wang, Jackie. *Carceral Capitalism* (New York: Semiotext(e), 2018).

Wilkins, Kristen S. 'Supplication, Photo Series - Kristen S. Wilkins',
Kristen S. Wilkins (2019) <https://www.kristenwilkins.com/
supplication#10> [Accessed 10 March 2019].

Willey, Nicola. 'Captive America: An Interview With Alyse
Emdur', *Venue* (2012) <http://v-e-n-u-e.com/Captive-America-
An-Interview-with-Alyse-Emdur> [accessed 11 March 2017].

Williams, Elizabeth and Russell, Sue. *The Illustrated Courtroom:
50 Years of Court Art* (New York: CUNY Journalism Press,
2014).

CULTURE, SOCIETY & POLITICS

The modern world is at an impasse. Disasters scroll across our smartphone screens and we're invited to like, follow or upvote, but critical thinking is harder and harder to find. Rather than connecting us in common struggle and debate, the internet has sped up and deepened a long-standing process of alienation and atomization. Zer0 Books wants to work against this trend. With critical theory as our jumping off point, we aim to publish books that make our readers uncomfortable. We want to move beyond received opinions.

Zer0 Books is on the left and wants to reinvent the left. We are sick of the injustice, the suffering, and the stupidity that defines both our political and cultural world, and we aim to find a new foundation for a new struggle.

If this book has helped you to clarify an idea, solve a problem or extend your knowledge, you may want to check out our online content as well. Look for Zer0 Books: Advancing Conversations in the iTunes directory and for our Zer0 Books YouTube channel.

Popular videos include:
Žižek and the Double Blackmain
The Intellectual Dark Web is a Bad Sign
Can there be an Anti-SJW Left?
Answering Jordan Peterson on Marxism

Follow us on Facebook
at https://www.facebook.com/ZeroBooks and Twitter at https://twitter.com/Zer0Books

Bestsellers from Zer0 Books include:

Give Them An Argument
Logic for the Left
Ben Burgis
Many serious leftists have learned to distrust talk of logic. This is
a serious mistake.
Paperback: 978-1-78904-210-8 ebook: 978-1-78904-211-5

Poor but Sexy
Culture Clashes in Europe East and West
Agata Pyzik
How the East stayed East and the West stayed West.
Paperback: 978-1-78099-394-2 ebook: 978-1-78099-395-9

An Anthropology of Nothing in Particular
Martin Demant Frederiksen
A journey into the social lives of meaninglessness.
Paperback: 978-1-78535-699-5 ebook: 978-1-78535-700-8

In the Dust of This Planet
Horror of Philosophy vol. 1
Eugene Thacker
In the first of a series of three books on the Horror of Philosophy,
In the Dust of This Planet offers the genre of horror as a way of
thinking about the unthinkable.
Paperback: 978-1-84694-676-9 ebook: 978-1-78099-010-1

The End of Oulipo?
An Attempt to Exhaust a Movement
Lauren Elkin, Veronica Esposito
Paperback: 978-1-78099-655-4 ebook: 978-1-78099-656-1

Capitalist Realism
Is There no Alternative?
Mark Fisher
An analysis of the ways in which capitalism has presented itself
as the only realistic political-economic system.
Paperback: 978-1-84694-317-1 ebook: 978-1-78099-734-6

Rebel Rebel
Chris O'Leary
David Bowie: every single song. Everything you want to know,
everything you didn't know.
Paperback: 978-1-78099-244-0 ebook: 978-1-78099-713-1

Kill All Normies
Angela Nagle
Online culture wars from 4chan and Tumblr to Trump.
Paperback: 978-1- 78535-543-1 ebook: 978-1-78535-544-8

Cartographies of the Absolute
Alberto Toscano, Jeff Kinkle
An aesthetics of the economy for the twenty-first century.
Paperback: 978-1-78099-275-4 ebook: 978-1-78279-973-3

Malign Velocities
Accelerationism and Capitalism
Benjamin Noys
Long listed for the Bread and Roses Prize 2015, *Malign Velocities*
argues against the need for speed, tracking acceleration
as the symptom of the ongoing crises of capitalism.
Paperback: 978-1-78279-300-7 ebook: 978-1-78279-299-4

Neglected or Misunderstood
The Radical Feminism of Shulamith Firestone
Victoria Margree
An interrogation of issues surrounding gender, biology,
sexuality, work and technology, and the ways in which our
imaginations continue to be in thrall to ideologies of maternity
and the nuclear family.
Paperback: 978-1-78535-539-4 ebook: 978-1-78535-540-0

How to Dismantle the NHS in 10 Easy Steps (Second Edition)
Youssef El-Gingihy
The story of how your NHS was sold off and why you will have
to buy private health insurance soon. A new expanded second
edition with chapters on junior doctors' strikes and government
blueprints for US-style healthcare.
Paperback: 978-1-78904-178-1 ebook: 978-1-78904-179-8

Digesting Recipes
The Art of Culinary Notation
Susannah Worth
A recipe is an instruction, the imperative tone of the expert, but
this constraint can offer its own kind of potential. A recipe need
not be a domestic trap but might instead offer escape – something
to fantasise about or aspire to.
Paperback: 978-1-78279-860-6 ebook: 978-1-78279-859-0

Most titles are published in paperback and as an ebook.
Paperbacks are available in traditional bookshops. Both print and
ebook formats are available online.
Follow us on Facebook
at https://www.facebook.com/ZeroBooks
and Twitter at https://twitter.com/Zer0Books